WASHINGTON THE STATE OF WINE

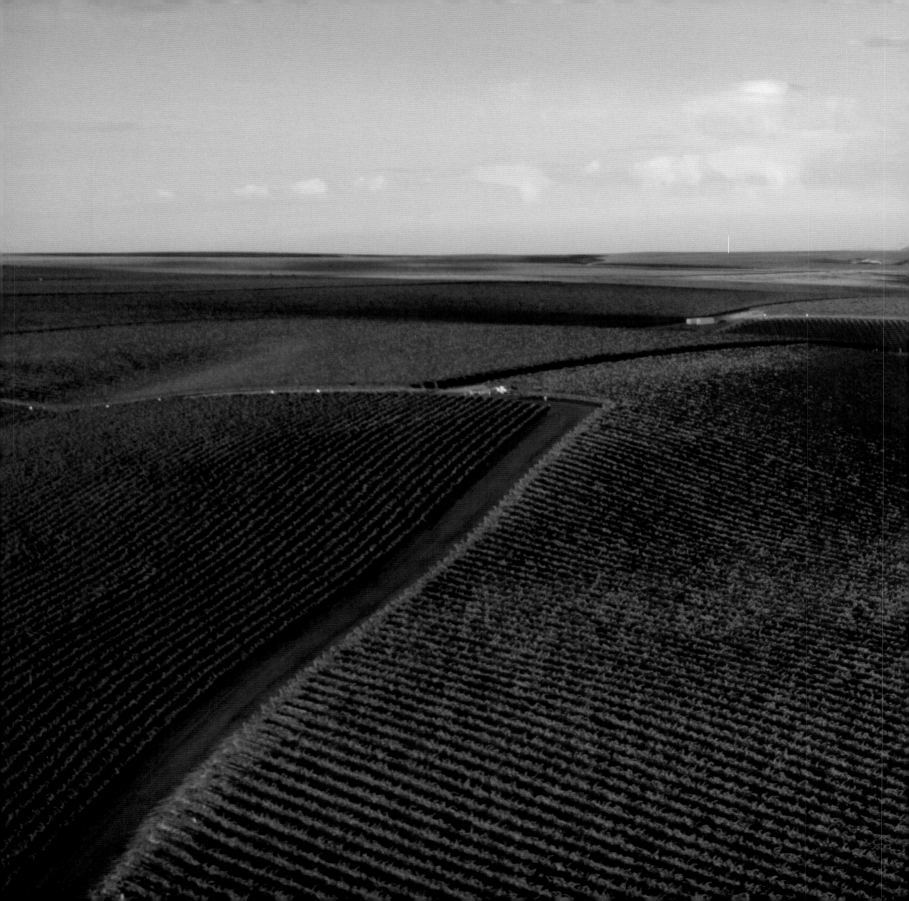

WASHINGTON
THE STATE OF WINE

Photographs by

Sara Matthews

Introduction by

Kevin Zraly

GRAPHIC ARTS BOOKS

Second printing

Library of Congress Cataloging-in-Publication Data

Matthews, Sara, 1959-
 Washington wine / photography by Sara Matthews.
 p. cm.
 ISBN-13: 978-1-55868-953-4 (hardbound) 1. Wine and wine making—Washington (State)—Pictorial works. 2. Vineyards—Washington (State)—Pictorial works. 3. Wine and wine making—Washington (State)—Miscellanea. I. Title.
 TP557.S228 2006
 641.2'209797—dc22

 2006013911

Graphic Arts Books
An imprint of Graphic Arts Center Publishing Company
P.O. Box 10306, Portland, Oregon 97296-0306
503/226-2402
www.gacpc.com

President: Charles M. Hopkins
Associate Publisher: Douglas A. Pfeiffer
Editorial Staff: Timothy W. Frew, Kathy Howard, Jean Andrews, Jean Bond-Slaughter
Production Staff: Richard L. Owsiany, Vicki Knapton
Designer: Brad Greene

Printed and bound in China

CONTENTS

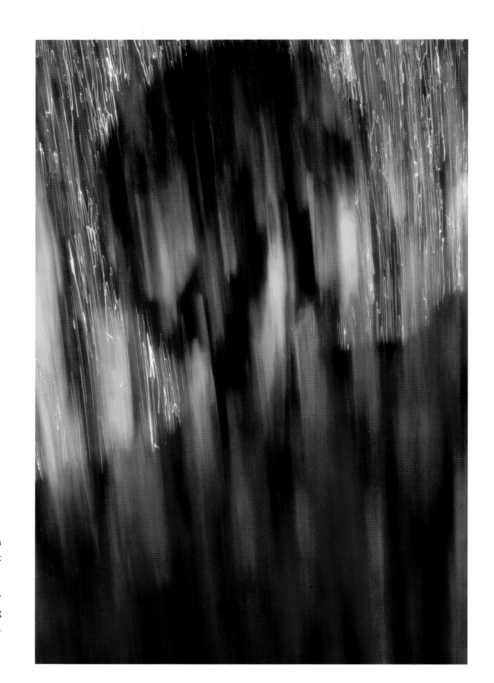

■ PREVIOUS PAGE: Residue from
pressed wine with grape seeds at
Betz Family Winery.

■ RIGHT: A winemaker's shadow
falling on fermented grapes being
poured into the press at L'Ecole N° 41.

PREFACE

By Sara Matthews

I've had the good fortune to photograph many of the great wine regions of the world, to kick the dirt with the vineyard manager, and taste the wine with the winemaker. After visiting hundreds of wineries, I've learned a lot about what it takes to make great wine and how to get the most out of any particular *terroir*.

Washington State is a relatively young wine region, but it has already developed into a world-class contender. I've watched it evolve rapidly since my first trip to the region in 2000. Today there are more vineyards, more wineries, and better wines. Wine lovers from all over the United States are discovering Eastern Washington. Restaurateurs and hotel owners have taken notice and are opening world-class establishments across the region, from the dramatic cliffs above the Columbia River to the historic downtown and rolling hills of Walla Walla. Most important, the wines are beginning to express their own distinctive character.

I've used my wide experience to try to show the reader what is most unique and advantageous about growing grapes and

making wine in Washington State. At the same time, I've pushed myself to develop as an artist, to reveal the beauty within the world of wine.

People often ask how I create my photographs. It is a combination of good planning, getting up before dawn to take advantage of the beautiful natural light, and trusting my visual instincts. When I'm shooting a photograph, I always ask myself, "What is this picture about?" For example, if it's an image of a person, I try to cut out any extraneous information in the image and to harmonize the composition. Sometimes it is a matter of cutting it down to the essential visual or emotional essence. I think of it as editing in action.

Winemakers also attempt to find the art in nature, in their work in the vineyards and the wineries. I would like to thank the wineries who agreed to sponsor the photography for this book and who trusted me to follow my artistic instincts as I captured these images: Betz Family Winery, Bookwalter Winery, Cayuse Vineyards, Chateau Ste. Michelle, Columbia Crest, Columbia Winery, Col Solare, DeLille Cellars, Hedges Family Estate, L'Ecole N° 41, Leonetti Cellar, Northstar Winery, Quilceda Creek Vintners, Snoqualmie Vineyards, Spring Valley Vineyard, and Woodward Canyon Winery.

PREFACE

Many people have helped me with this book. I owe special thanks to Tom Hedges for encouraging me to put the book together, Steve Burns for his belief in the project and in my abilities, Keith Love for all his advice and support, Bob Betz and Marty Clubb for their guidance, and Ted Baseler for agreeing to sponsor six wineries for Ste. Michelle Wine Estates. Laura LoPresti, my trusty photography assistant and friend, has been invaluable, and her business, Washington Wine Tours, is a wonderful resource for wine lovers traveling through the region.

Thankfully, my husband, Tom Matthews, was supportive as always, even though this project kept me away from home for many weeks.

It has been a great pleasure photographing the fine people of this region, from the vineyard workers to the winemakers. Their hard work makes Washington the State of Wine.

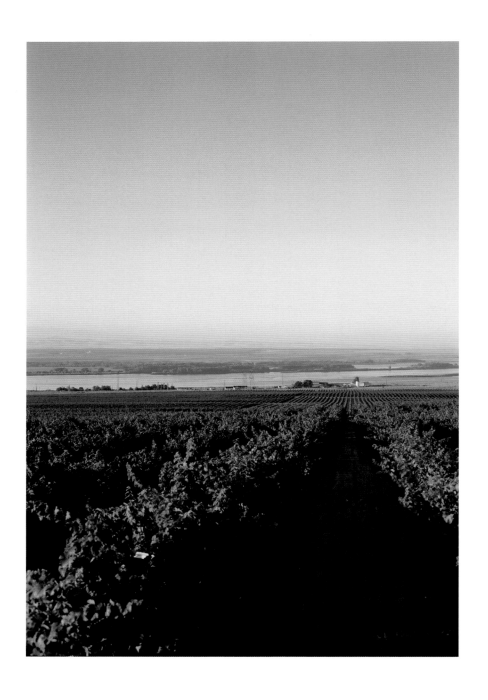

INTRODUCTION

By Kevin Zraly

As a wine educator, I first mentioned the vineyards and wines of Washington State in the early '70s, a few years after Washington produced its first quality wine. Fast forward forty years later, and Washington State has now matured to be one of the great wine regions of the world.

For many reasons it took longer for Americans to understand and appreciate the wines of Washington State. Ask anyone about this northwest region and one of the first responses is "How do you make great wine in a rainy climate like Seattle's?"

But in reality there are two Washingtons: the east and the west, divided by the Cascade Mountains, which is a chain of volcanos, including Mount Rainier and Mount St. Helens. On the east side of those mountains, geologic cataclysms—dramatic lava flows fifteen million years ago, the monstrous floods during the last ice age—created ideal soil conditions for growing superior grapes and making high-quality wine. It's a change from west coast maritime

■ PREVIOUS PAGE: Columbia Crest's vineyards overlooking the Columbia River in the Horse Heaven Hills AVA.

to a continental climate. The eight inches of rainfall, compared to up to sixty inches in Seattle, means that eastern Washington has the arid, hot days where wine grapes thrive. This wine-growing region also has an irrigation system partly sourced from the Columbia River that produces perfectly ripe grapes.

Unlike California, Washington State doesn't have a long history of winemaking. It's definitely less about the past and more about the present and the future.

∽

All of this has happened very fast. It has not been BAM but BOOM! Some say, "A new winery opens in Washington every week." There were ten wineries in 1970, but today there are more than four hundred. It was wheat to grapes, orchards to vineyards, Riesling to Red (think Cabernet Sauvignon, Merlot, and Syrah). But Washington is still the number-one producer of Riesling in the U.S., and its Chardonnays are popular because of their balance, great fruit, and lively acidity. The wine-growing appellations (there are eight in all) have interesting-sounding names like Horse Heaven Hills, Walla Walla Valley, Wahluke Slope, Yakima Valley, Puget Sound, and easier names like Columbia Gorge, Columbia Valley, and Red Mountain. These American Viticultural Areas

INTRODUCTION

("AVAs") combine to make Washington the number-two fine wine-producing state in the United States.

There are some things words cannot describe. That's when the art of the photographer tells the story through her eyes. Sara Matthews has been able to capture the rocks, the soil, the rivers, the desert, and the irrigation, which give life to the vines. It might be a good idea to listen to some classical music as you view her work and see the beauty of the vineyards at sunset, the dry lands, vine after vine, the color of the grapes before harvest, and the juice during fermentation. Sara gives you the feeling that you are there. Her photos take you from the old wooden barrels to the new stainless steel to the early pioneers of Washington State wines, to the new owners and winemakers, both young and old. What Sara has always accomplished throughout her photographic career is to highlight the most important aspect of grape growing and winemaking—the cross section of people who tend the vines, pick the grapes, and help to give pleasure to all of us wine lovers.

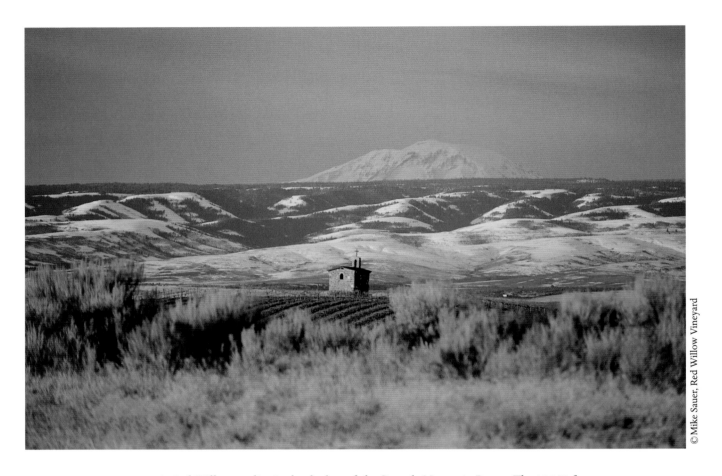

At Red Willow, we live in the shadow of the Cascade Mountain Range. The 12,300-foot Mount Adams dominates the landscape of the western end of the Yakima Valley. Often the stormy gray rain clouds are seen gathered over the Cascades, but they come no farther. The rain-shadow effect of the Cascades once again divides the wet, lush, and green west side of the state from the desert sagebrush-covered region of Eastern Washington. This same Cascade Mountain Range has provided the volcanic material that dominates much of the Red Willow soil profile, even as recently as 1980, with the eruption of Mount St. Helens.

Mike Sauer

RED WILLOW VINEYARD

Local Color

Spurred by Lewis and Clark's reports of the area's resources, French Canadian trappers established Fort Vancouver and Fort Walla Walla in the early 1820s. The town of Walla Walla emerged as a boomtown in the Pacific Northwest during the Idaho gold rush of 1860. Once the gold rush ended, farming anchored the economy and spread extensively through the Columbia Basin and into the Yakima Valley. Wheat fields thrived then, as they still do today. Grape growing began in the 1850s, with nurseries and wineries in Walla Walla ultimately spreading into the Yakima Valley. The industry disappeared with Prohibition; the modern era emerged in the 1970s with the rapid growth of Ste. Michelle Wine Estates and the Associated Vintners. Smaller wineries throughout the Yakima Valley, Columbia Basin, and Walla Walla were going strong by the early 1980s.

Marty Clubb

OWNER AND WINEMAKER, L'ECOLE N°41

■ PREVIOUS PAGE: The "Chapel of the Vine" at Red Willow Vineyard with the Cascade Mountain Range and Mount Adams (12,276 feet).

■ RIGHT: Misty evergreens in the mountains near Quilceda Creek, in Snohomish, on the western side of the Cascade Mountains.

■ BELOW: Sagebrush flourishes in Alder Canyon near Champoux Vineyard in the Horse Heaven Hills AVA, on the eastern side of the Cascade Mountains.

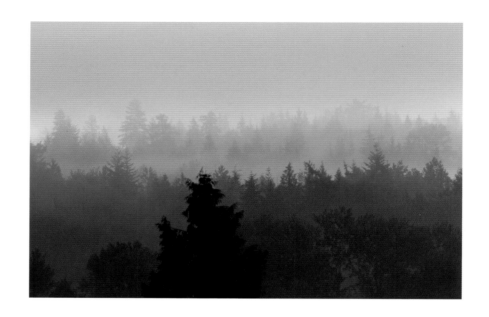

The wonder of the transition from the green forests of the western coast up into the alpine region of the Cascade passes, down through the open ponderosa pine country, and then into the majestic broadbrush landscape where our vineyards grow, never ceases to stir the soul.

David Lake

DIRECTOR OF WINEMAKING,
COLUMBIA WINERY

LOCAL COLOR

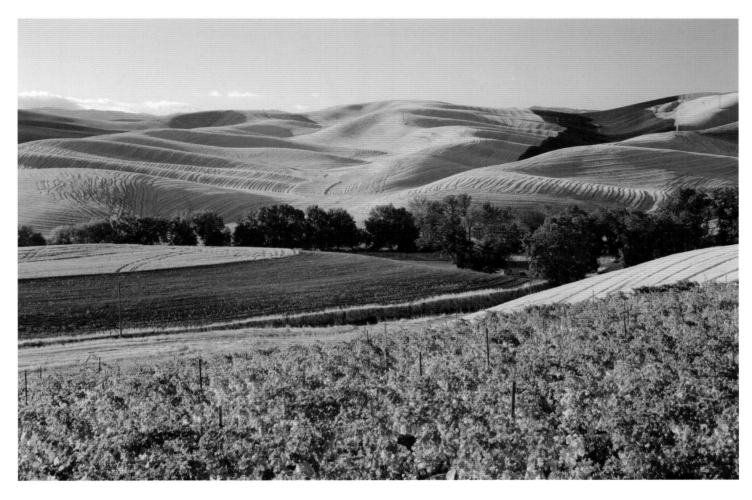

■ ABOVE: Spring Valley Vineyard
and wheat fields in Walla Walla.

■ RIGHT and BELOW: Spring Valley Vineyard and wheat fields in Walla Walla.

■ OPPOSITE: Natural landscape around the vineyards of Woodward Canyon Winery.

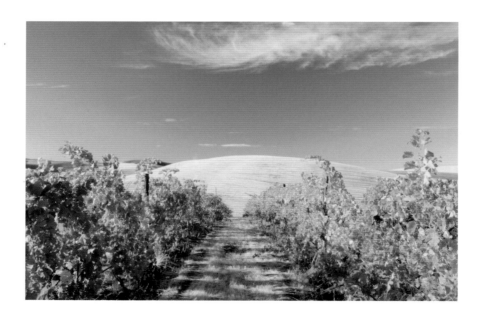

LOCAL COLOR

My family has farmed wheat in Eastern Washington for a hundred years. In 1991 we planted our first vineyard in the middle of our wheat fields, and we started making wine with the 1999 vintage. We decided to put the pictures of our ancestors on our wines bottles. It was our way of connecting our past to the present.

Shari Corkrum Derby
FOUNDER, SPRING VALLEY
VINEYARD

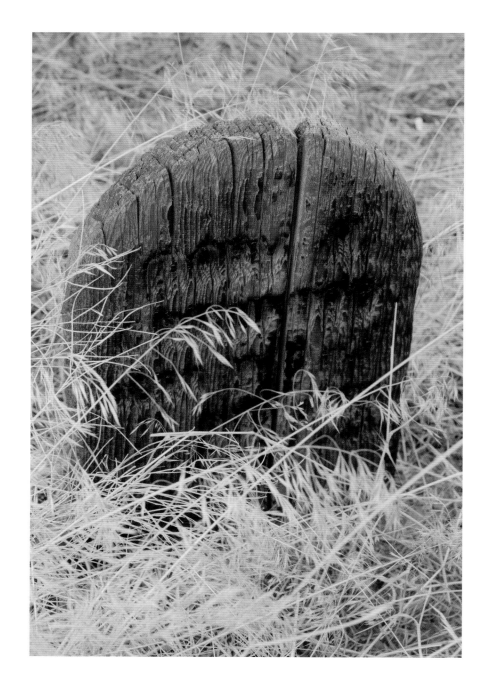

■ RIGHT: Grave marker made of wood in a field near Walla Walla.

■ OPPOSITE: Gravestones and old iron railings in a wheat field near Walla Walla.

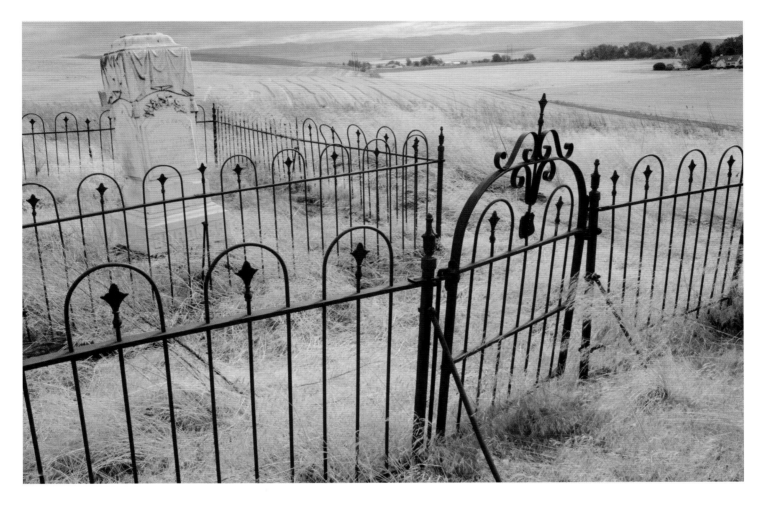

The settlement of Eastern Washington was different from the settlement

of Seattle. We had rangeland. Sagebrush. Wild horses. Cowboys.

~ *Shari Corkrum Derby*

FOUNDER, SPRING VALLEY VINEYARD

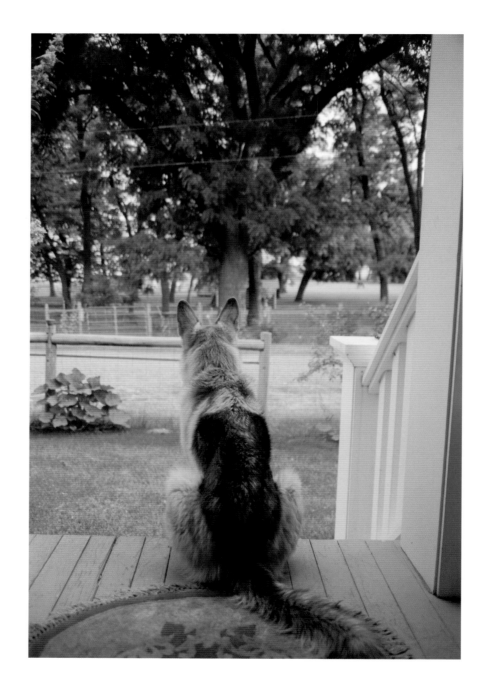

RIGHT: Shari and Dean Derby's dog, Sage, watching over the garden.

■ OPPOSITE: The Derbys on the porch of the house built by Shari's grandfather Uriah Corkrum, for whom they named one of their Spring Valley Vineyard wines.

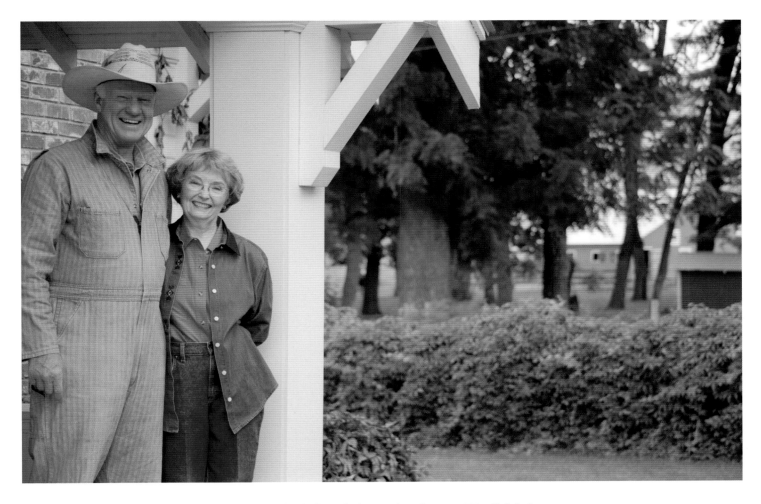

Early in the twentieth century, my family farmed wheat with mule teams. We called the handlers mule skinners. So we named one of our Spring Valley wines "Mule Skinner."

Shari Corkrum Derby
FOUNDER, SPRING VALLEY VINEYARD

■ RIGHT: Fuel pumps and farm dog at Red Willow Vineyard in the western part of the Yakima Valley.

■ BELOW: The license plate on Christophe Baron's old Ford truck refers to Walla Walla Syrah.

■ OPPOSITE: Old red barns on a farm near Walla Walla, circa 1910.

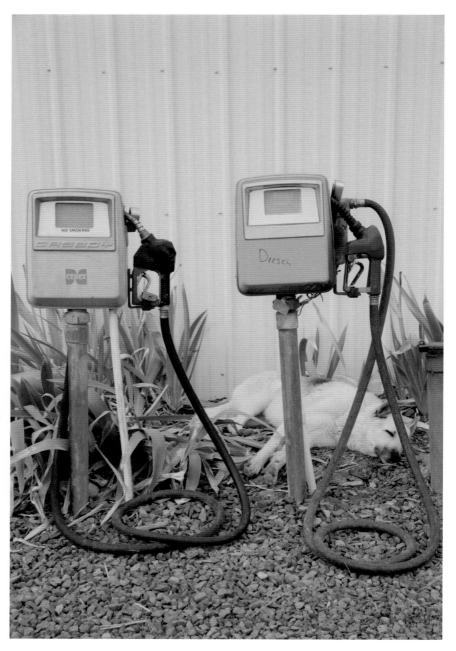

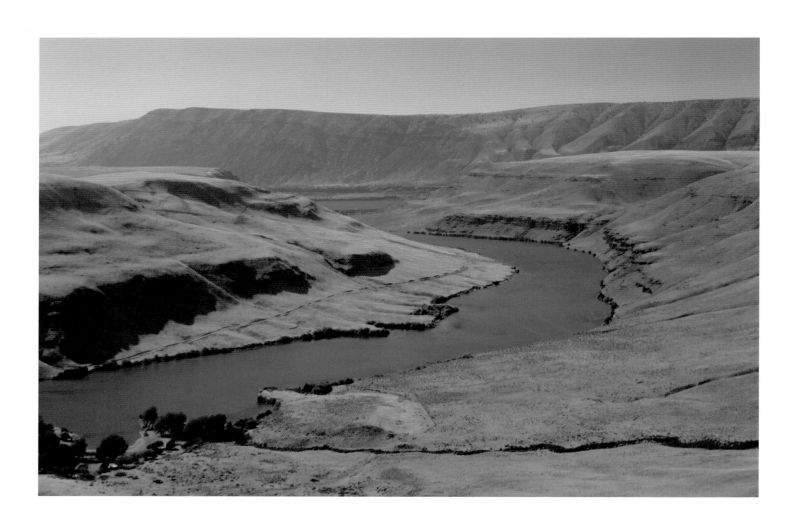

Missoula Floods

Most vineyards in Eastern Washington lie within the Columbia Basin, an area that was inundated by huge eruptions of lava around fifteen million years ago. These lavas hardened into basalt, a dark iron-rich volcanic rock, which now forms a layer several miles thick beneath the surface sediment in the vineyards in the south-central part of the Columbia Basin.

Around fifteen thousand years ago, during the most recent ice age, the Columbia Basin flooded again, but this time by water, not lava. A huge lobe of ice flowed south out of Canada and blocked the Clark Fork River in the Idaho Panhandle, creating glacial Lake Missoula, which was the size of one of our modern-day Great Lakes. The water behind the ice dam slowly rose until it was deep enough to float the ice, releasing all of the water in a colossal flood that swept across Eastern Washington and down the Columbia River Gorge.

■ PREVIOUS PAGE: Lake Umatilla
behind the John Day dam on the
Columbia River, near Goldendale,
Washington. During the floods, the
water would have covered the
"benches" on each side of the water.

■ OPPOSITE: Wallula Gap on the
Columbia River.

This scenario repeated itself many times as the glacier surged southward, rebuilding the dam. Where the currents were strongest, these "Missoula floods" eroded deep channels or coulees in the basalt bedrock.

The final resting place of the icebergs is marked by nonnative, or erratic, rocks such as granite and quartzite. At elevations below twelve hundred feet, the maximum height of the floodwaters, the Walla Walla Valley contains up to one hundred feet of glacial flood sediments, known as Touchet beds, which were deposited by as many as forty Missoula floods.

After each flood drained, it left behind a dry, sediment-covered landscape. Some of this sediment was picked up and blown to the northeast by the prevailing southwest winds, blanketing the land above the Missoula floodwaters with a thick accumulation of loess, which formed the thick, silt-rich soils of the Palouse country of Eastern Washington. The well-drained soils of the Palouse proved to be ideal for growing wheat, and now are home to world-class vineyards.

Kevin Pogue

PROFESSOR OF GEOLOGY, WHITMAN COLLEGE

MISSOULA FLOODS

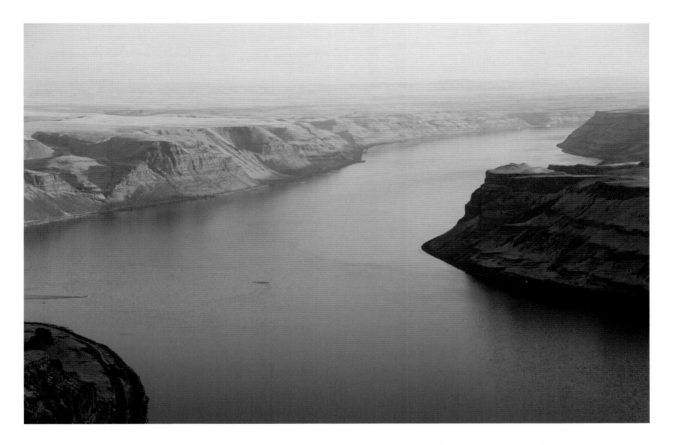

The Wallula Gap was a bottleneck for the Missoula Floods, which backed up behind the narrow canyon, creating a lake that flooded the lower Columbia Basin, including the Yakima and Walla Walla Valleys. Most of the vineyards in these valleys are rooted in well-drained soils composed of fine sand and silt deposited in the lake.

~ Kevin Pogue

PROFESSOR OF GEOLOGY, WHITMAN COLLEGE

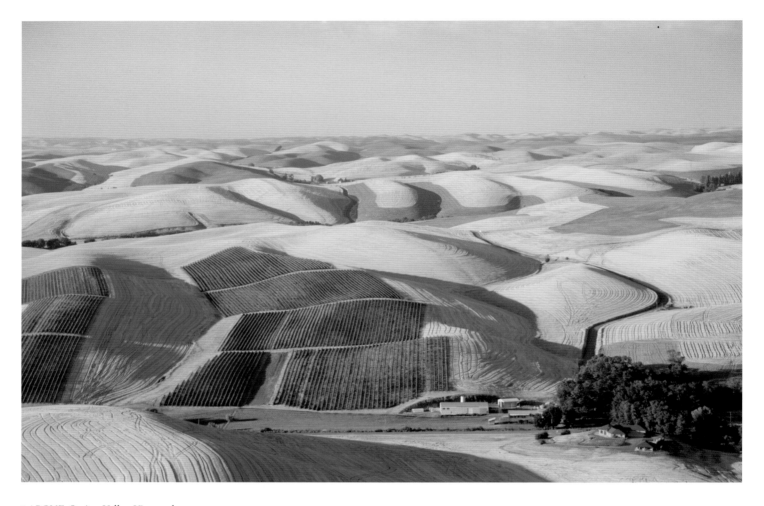

■ ABOVE: Spring Valley Vineyard,
an estate winery in the Walla Walla
Valley.

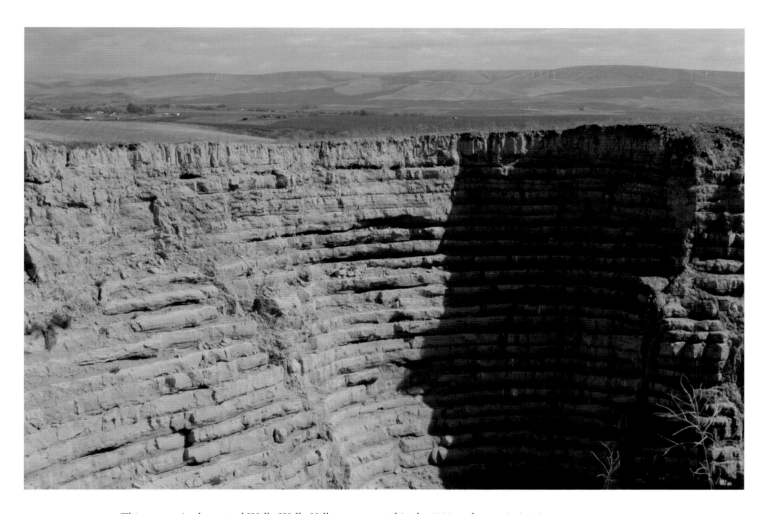

This canyon in the central Walla Walla Valley was created in the 1920s, when an irrigation canal was diverted. The flowing water exposed each of the thirty-nine layers of flood sediments left behind by consecutive Missoula Floods. In this area, which is typical of the Walla Walla Valley AVA, the well-drained sands and silts are capped by about three feet of wind-deposited silt known as loess.

~ Kevin Pogue

PROFESSOR OF GEOLOGY, WHITMAN COLLEGE

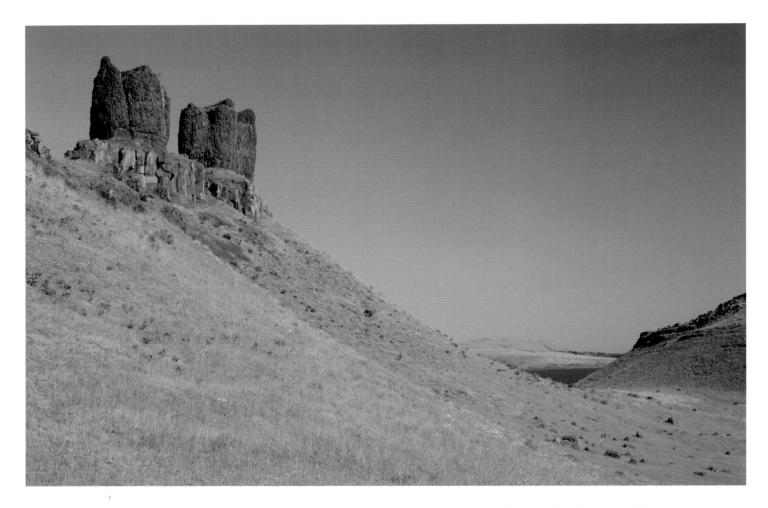

The force of the floodwaters that originated from Lake Missoula tearing though the gap peeled away the lava flows of the Columbia River basalts up to an elevation about 800 feet above the level of today's Columbia River, visible in the photo, to create a fantasy landscape high on the walls of the gap, such as the Twin Sisters.

Alan Busacca

PROFESSOR OF SOIL SCIENCES, WASHINGTON STATE UNIVERSITY

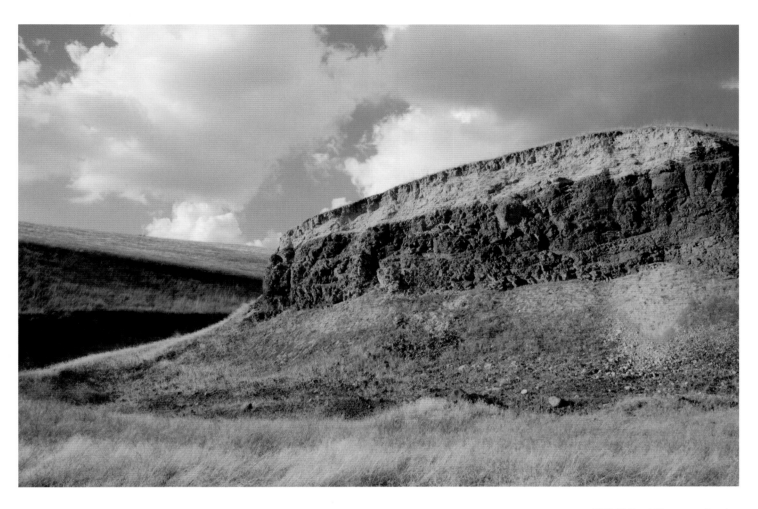

■ ABOVE: Roadside quarry showing the basalt bedrock typical of Eastern Washington, with a three-foot layer of windblown loess on top, near Woodward Canyon Estate Vineyard.

Vigneron Christophe Baron of Cayuse crafts Rhone-varietal wines that truly express the wild terroir of the stones at his Cailloux Vineyard on the floodplain of the postglacial course of the Walla Walla River near Milton-Freewater, Oregon, in the Walla Walla Valley AVA. These soils are formed of nearly pure, rounded basaltic cobbles from the nearby Blue Mountains.

Alan Busacca

PROFESSOR OF SOIL SCIENCES,
WASHINGTON STATE UNIVERSITY

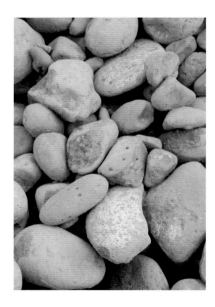

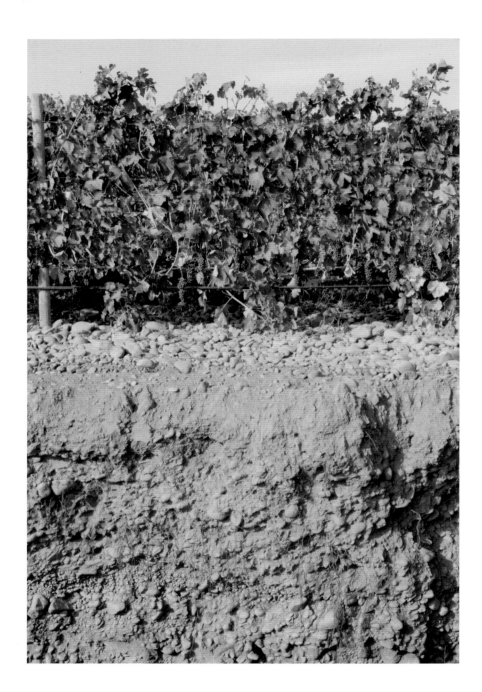

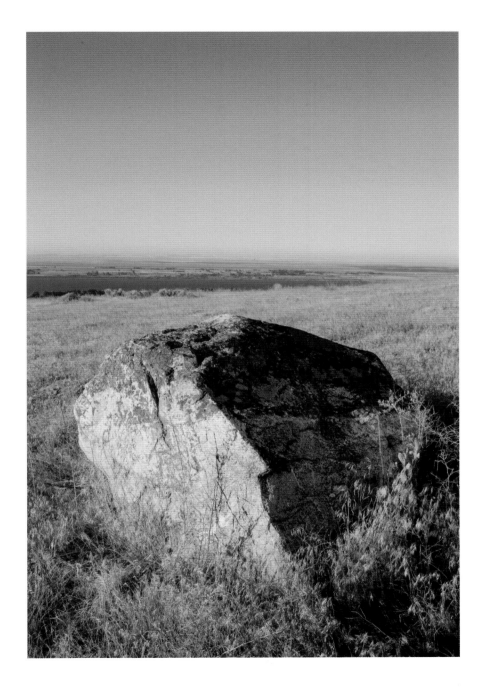

■ OPPOSITE: Cayuse Vineyards in Walla Walla.

■ LEFT: A granite boulder in Canoe Ridge Estate, which marks the final resting place of a large iceberg carved from the glacial ice dam that formed Lake Missoula.

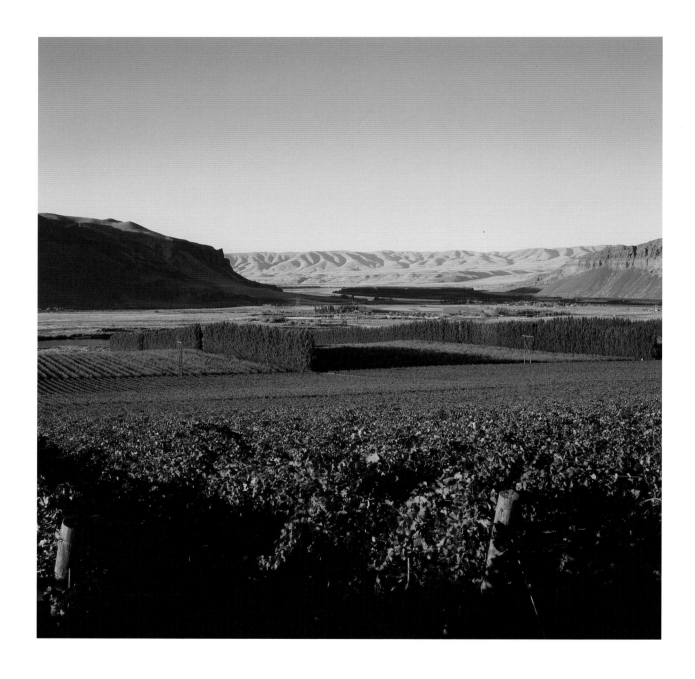

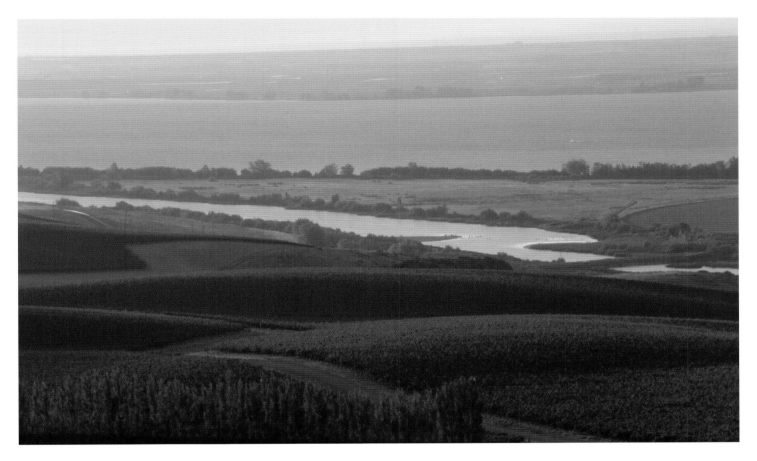

Until I saw Canoe Ridge Estate (above) from the air, I did not appreciate how the Missoula Floods created a landscape that is ideal for growing wine grapes. The floods blasted through here with such a force, they sculpted ridges facing the Columbia River that are ideal for grapes because they have poor soils that drain well. It is clear that most of the rich soils were scoured out and carried to the Pacific Ocean all those years ago. That's just fine with grapes.

Mimi Nye

VINEYARD MANAGER, STE. MICHELLE WINE ESTATES

■ OPPOSITE: This vineyard in Beverly, Washington, overlooks Sentinel Gap, where the Columbia River passes through a deep notch carved into the basalt by the Missoula Floods.

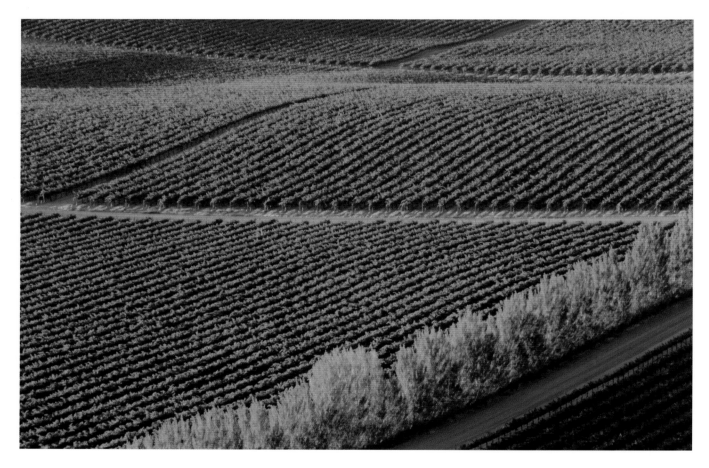

Washington's vineyard climate is unique. The dry, rain-shadow climate, at the 46th parallel of latitude, has no match anywhere else on earth. Winters can be severe, but some adversity builds character in grapevines, and during the growing season conditions are ideally suited to the growing of world-class wines. This unique climate is remarkably versatile, permitting the successful cultivation of a range of fine grape varieties that have their origins in France, Germany, and Italy.

David Lake

MASTER OF WINE, DIRECTOR OF WINEMAKING, COLUMBIA WINERY

Vineyards

Washington State winegrowers have implemented environmentally friendly sustainable vineyard programs tailored for our soils and growing climate. Our cold, dormant winters and arid, sunny summers naturally inhibit pests and mildew pressures. On top of this ideal stage, we have focused on building healthier soils and nurturing beneficial microorganisms through the use of organic composts. Healthy soils generate healthy vines, which are more naturally resistant to pests and disease, and produce better-quality fruit. We feel that we have the perfect climate for wine.

Marty Clubb

OWNER AND WINEMAKER, L'ECOLE N° 41

We have been intrigued for some time with the growing conditions and terroir in Washington State. This is a region with the potential to make some of the finest wines in the world.

~ Marchese Piero Antinori

PARTNER WITH STE. MICHELLE WINE ESTATES IN COL SOLARE

■ PREVIOUS PAGE: Rhythmic patterns at Canoe Ridge Estate, on the banks of the Columbia River in the Horse Heaven Hills AVA.

■ RIGHT: A baby Tempranillo vine in the rocky soil at Cayuse in Walla Walla.

■ OPPOSITE: A scarecrow at Spring Valley Vineyard warding off hungry birds from the neighboring wheat fields.

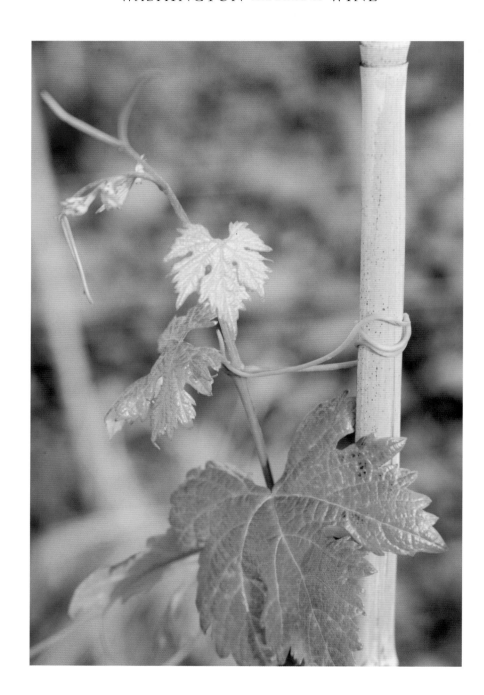

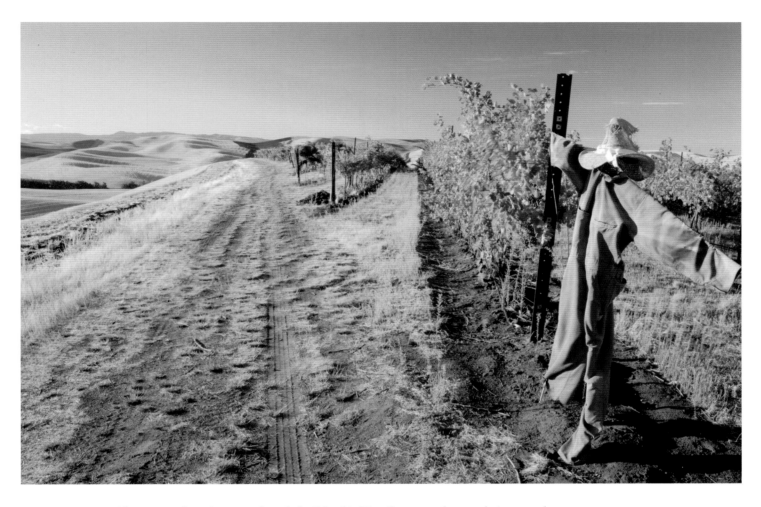

The amount of wind coursing through the Columbia River Gorge caused us to redesign our trellis system for prevention against windburn. The underlying benefit of the wind is that it causes the berry to thicken its skin to protect the nectar inside. This produces more characteristic varietal flavors in the wine.

~ *Paul Champoux*
OWNER AND OPERATOR, CHAMPOUX VINEYARDS

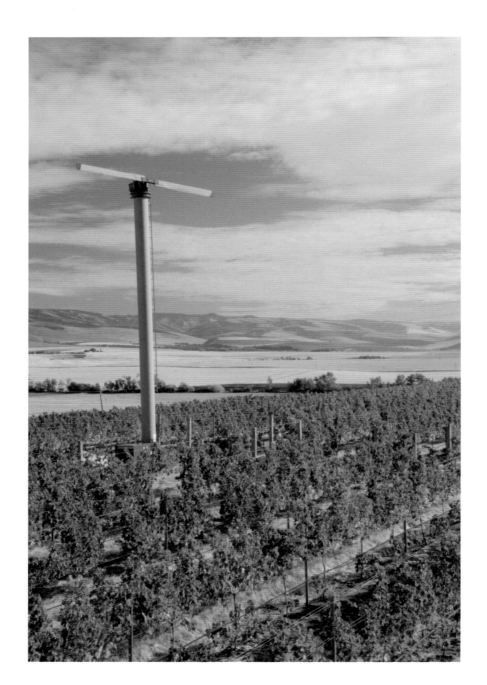

■ RIGHT: Leonetti Cellar's Loess Vineyard adjacent to the winery in Walla Walla.

■ OPPOSITE: Vineyards at North-star Winery, which is known for its Merlot.

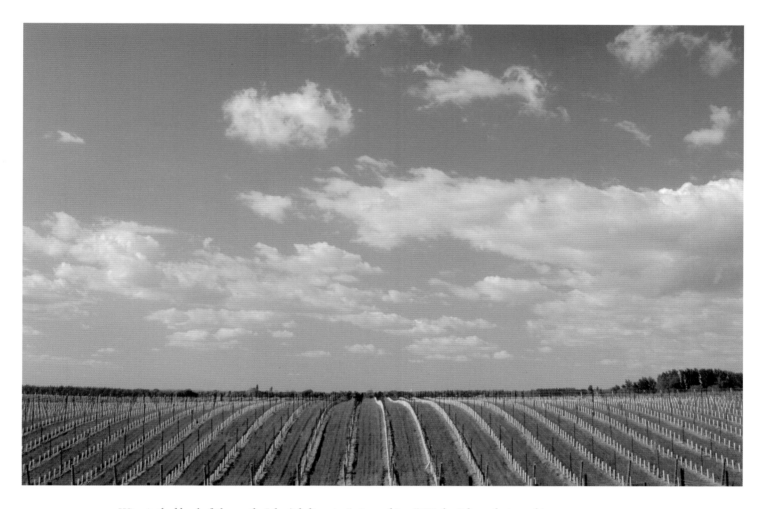

Wine is the blood of the earth. I don't believe in "winemaking." We don't have that word in French. I believe in hard work in the vineyards—that's 90 percent of it. I'm a farmer, not a winemaker. My goal is to create wines with character, personality, and individuality.

Christophe Baron

VIGNERON, CAYUSE VINEYARDS

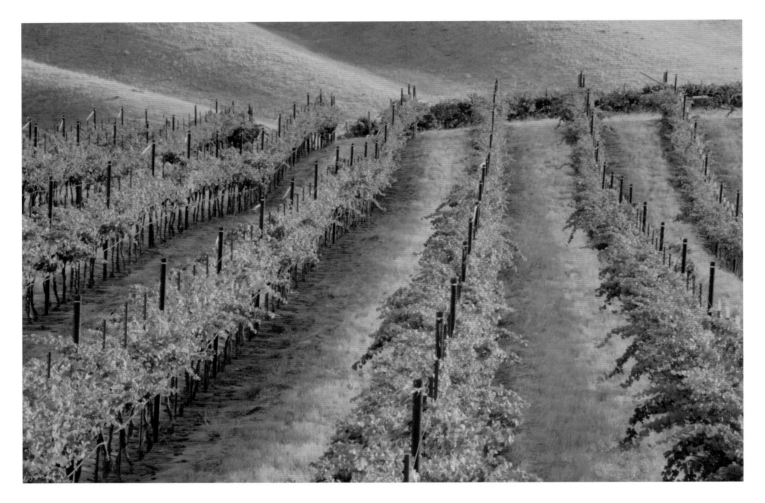

The secret is out about Washington State. This unlikely place to produce fine wine is emerging as one of the premier wine regions of the world. The grapes thrive in the long hot summer days and cool nights east of the Cascades. And we have a control over water that is the envy of many other regions.

~ Ted Baseler

PRESIDENT, STE. MICHELLE WINE ESTATES

VINEYARDS

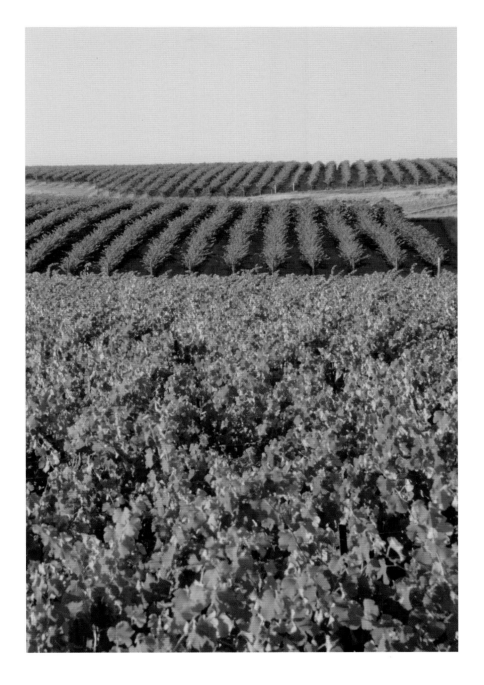

■ OPPOSITE: Woodward Canyon Estate Vineyard in the Walla Walla AVA.

■ LEFT: Rolling hills provide good drainage at McKinley Springs Vineyard in the Horse Heaven Hills AVA.

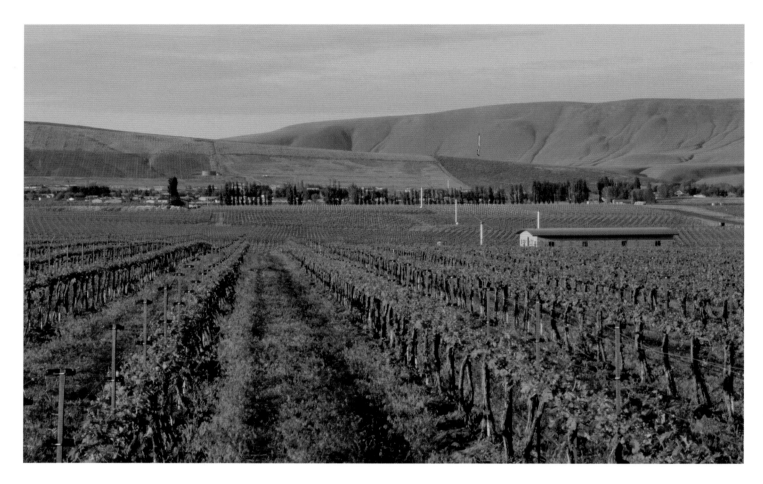

■ ABOVE: DeLille Cellars' Grand Ciel Vineyard and Quilceda Creek's Galitzine Vineyard in Red Mountain AVA, with the Horse Heaven Hills in the distance.

■ OPPOSITE: The Yakima River winding its way along the side of Fred Artz's vineyard in Red Mountain, with Rattlesnake Mountain in the distance.

VINEYARDS

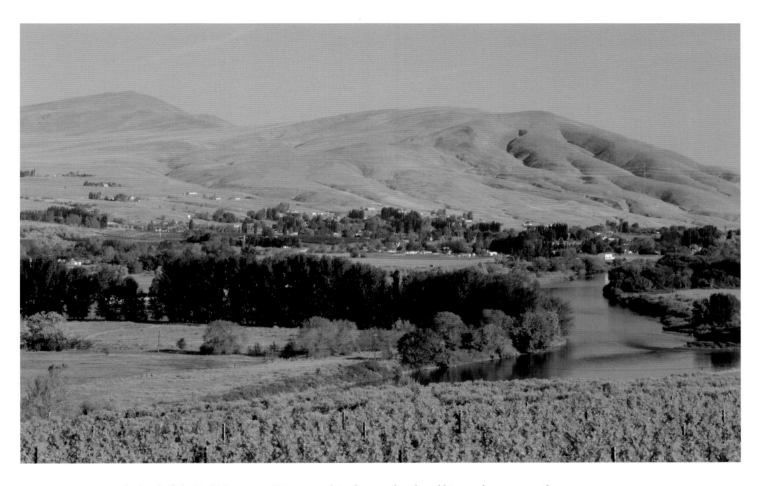

The land of the Red Mountain AVA was nothing but sagebrush, rabbits, and coyotes until the 1960s. It could be bought for next to nothing, but it became quickly apparent, after grapes were first planted by the Williams family in 1975 as a hobby, that the wines were different. The Red Mountain name was first used in 1906 by a local apple grower, who named his property Red Mountain Orchards. The upper mountain turns a bright reddish color in early spring as the "cheat grass" blooms, supposedly named because it cheated Western cattle farmers out of good rangeland in the 1800s.

Tom Hedges
FOUNDER AND OWNER, HEDGES FAMILY ESTATE

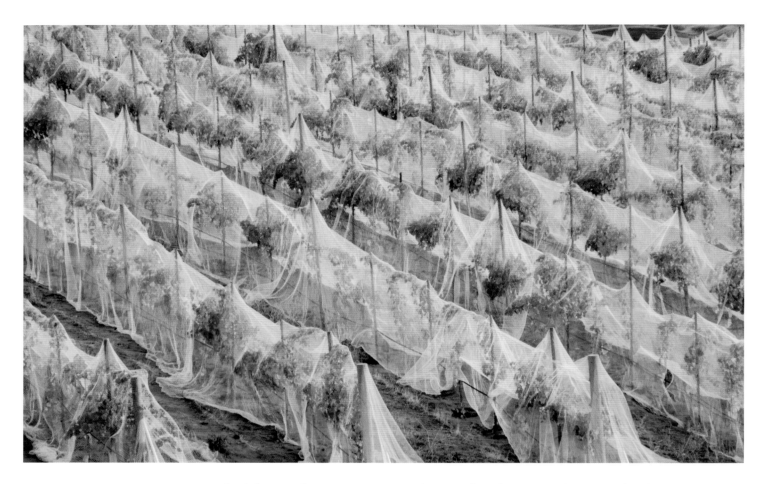

I dearly love spending time in our vineyard. Very early in the morning, the air is cool and clean and it smells fresh and earthy—real. I am the third generation to walk and work on our land. First it was virgin land, then wheat and livestock were raised there. Now it is wine grapes. It is almost spiritual sometimes when I am up there and think about it. It makes me remember my dad and grandfather. It reminds me of my roots, and grounds and anchors me. I have a sense of place, just like my wines do.

~ Rich Small

OWNER AND DIRECTOR OF PRODUCTION, WOODWARD CANYON WINERY

■ OPPOSITE and LEFT: Netting protects the ripening grapes against hungry birds at Woodward Canyon's vineyards.

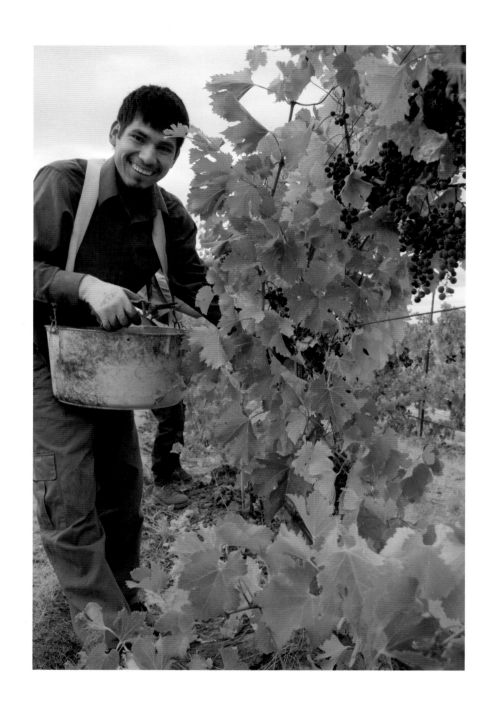

CHAPTER FOUR

Work

―――――――

Creating extraordinary wines requires extraordinary efforts from many extraordinary people. Wine is grown by farmers, not "made" by human hands in the winery. It is the product of grapes, and grapes alone—a true reflection of location and the hard labors of many dedicated migrant families. The harsh desert climate is their workshop. They endure through summer and winter. They care for the vineyards—watching, and feeling—protecting one grapevine at a time. It is these dedicated efforts that yield autumn's prized bounty.

Washington grape growing and winemaking is still in the very early stages, where anything goes. Grape growers and winemakers take chances on unproven sites and varieties with little deference to historical practices. And this is a good thing! This unfettered approach is creating a collegial atmosphere of competition, which propels quality at a torrid pace.

John Bookwalter

PRESIDENT AND WINEMAKER, BOOKWALTER WINERY

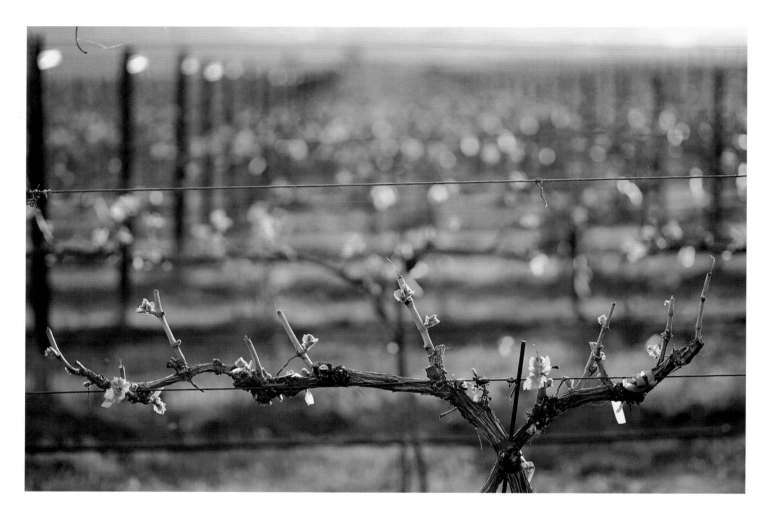

■ PREVIOUS PAGE: Orlando Torres harvesting grapes at Spring Valley Vineyards.

■ ABOVE: Bud break in Hedges Estate Vineyard in the spring.

Every year is a new venture, every crop a new plan for winemaking and marketing. There is no substitute for growing the right grape varieties in the right place, or for having local pruners, tillers, tractor drivers, and human-harvesters who learn the vineyard and terroir. Increasing this knowledge year to year is necessary for constant quality improvement.

~ *Tom Hedges*

FOUNDER AND OWNER, HEDGES FAMILY ESTATE

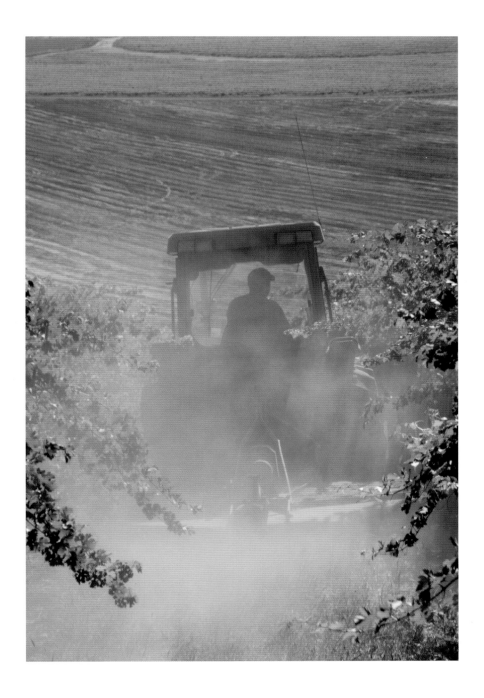

■ LEFT: At Champoux Vineyards in the Horse Heaven Hills AVA, grass is mowed between the rows to distribute organic matter to the vine and create sun reflection to the fruiting zone.

■ ABOVE: A tiller at Columbia Crest, which is used to aerate the soil between the vines in spring and summer.

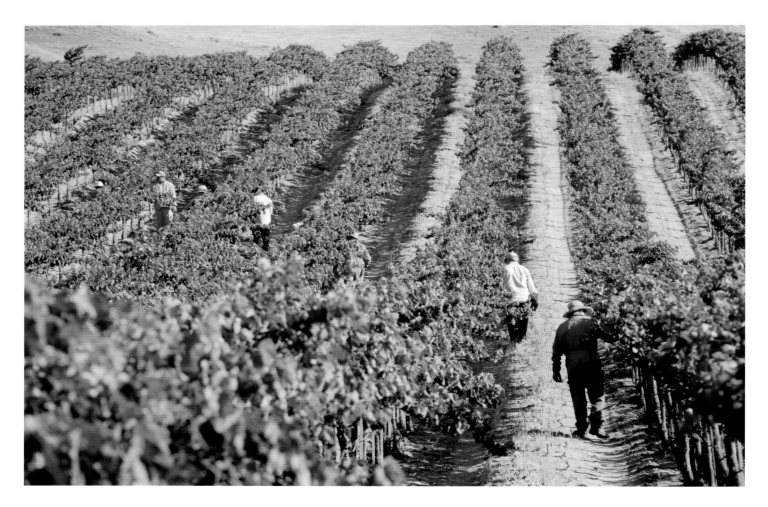

Quality wine is made in the vineyard, where meticulous attention to detail pays dividends in the bottle. This includes a combination of hard pruning to reduce yield, shoot thinning for balance, deficit drip irrigation for controlled canopy and cluster weight, and green thinning at veraison.

~ *Marty Clubb*
OWNER AND WINEMAKER, L'ECOLE Nº 41

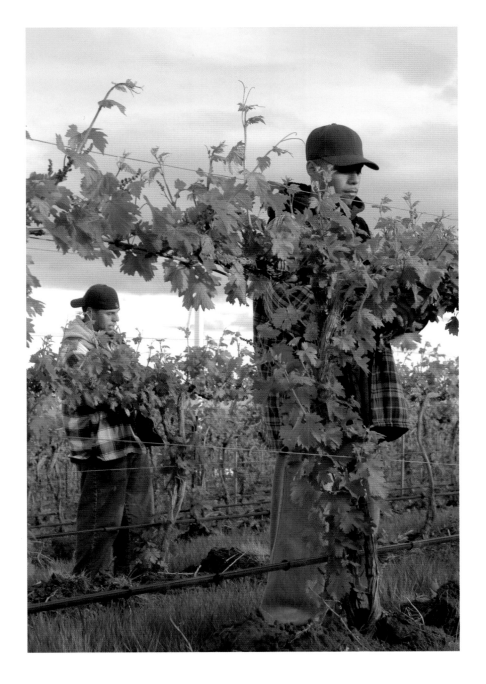

■ OPPOSITE: Workers at Canoe Ridge Estate thinning clusters of grapes in late summer to lower yields and promote uniformity of ripeness.

■ LEFT: Workers tying vines onto the wires in early summer at Seven Hills Vineyard. At this time, they also pull off the leaves growing from the base of the vine, to concentrate the vine's growth into the canopy of leaves and the grapes themselves.

Green thinning of grape clusters is a practice used by high-quality growers to yield the best balance of fruit to canopy, and promote more even and consistently ripe, high-quality fruit.

~ *Jerry Bookwalter*

OWNER AND WINEMAKER,
BOOKWALTER WINERY

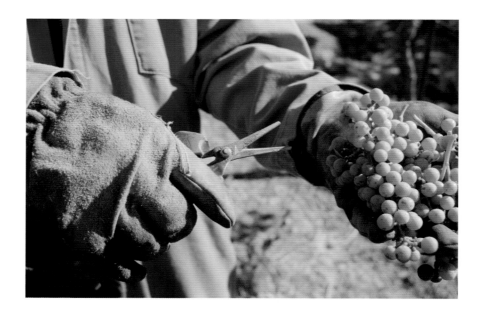

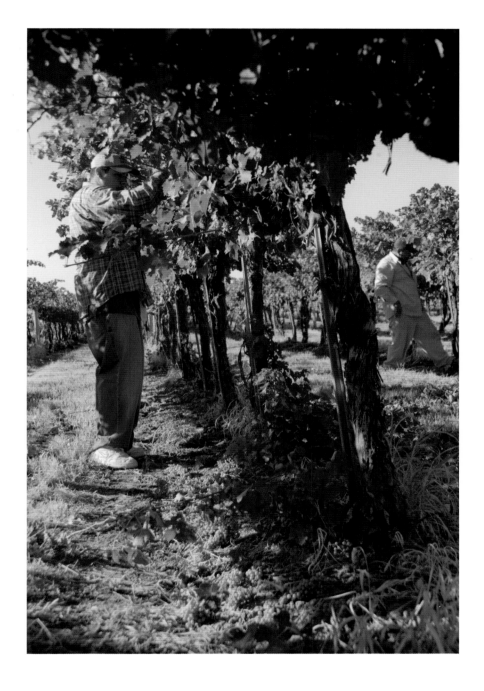

■ OPPOSITE TOP: The dark red grapes were dropped a few weeks before the freshly cut bunch, which is just going through veraison, or turning of color.

■ OPPOSITE BOTTOM: Workers go through the vineyard dropping bunches of grapes twice at Canoe Ridge Estate.

■ LEFT: Workers dropping Cabernet Sauvignon grapes from vines planted in 1979, some of the oldest in Washington State, at Champoux Vineyards, in Horse Heaven Hills AVA.

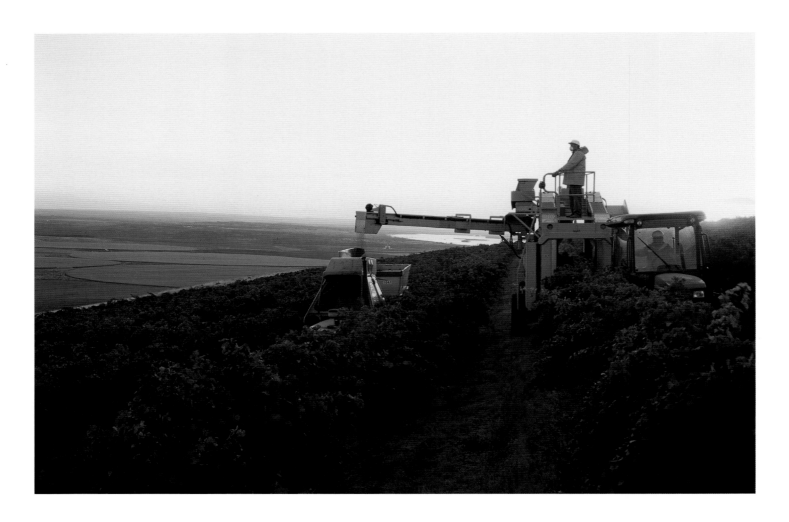

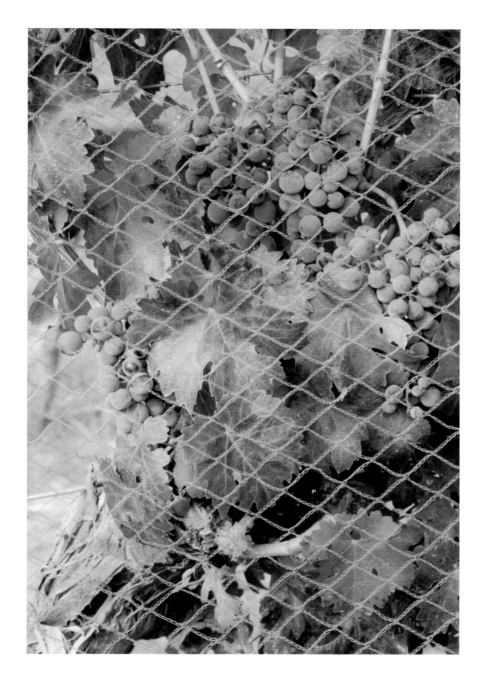

■ OPPOSITE: At Canoe Ridge Estate, harvest takes place during the night in order to bring cool grapes into the winery to avoid having the fermentation start up too fast.

■ LEFT: Nets protect the grapes on the oldest vines in Washington State, planted in the Harrison Hill Vineyard in 1962, near Sunnyside.

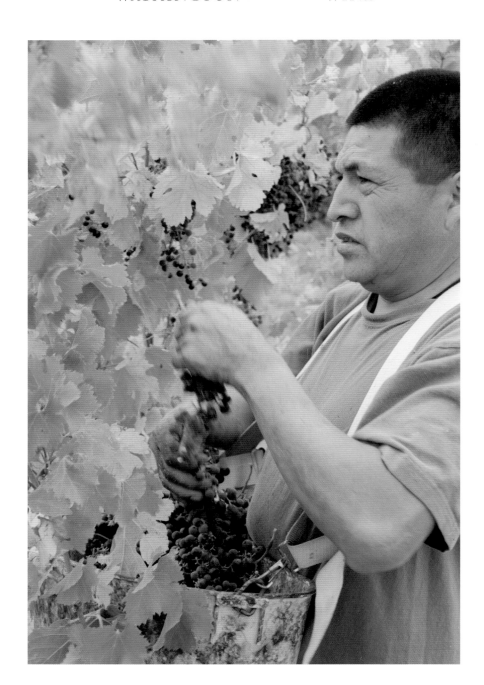

■ RIGHT: Cesar Jimenez harvesting grapes at Spring Valley Vineyard.

■ OPPOSITE: Harvest at Spring Valley Vineyard.

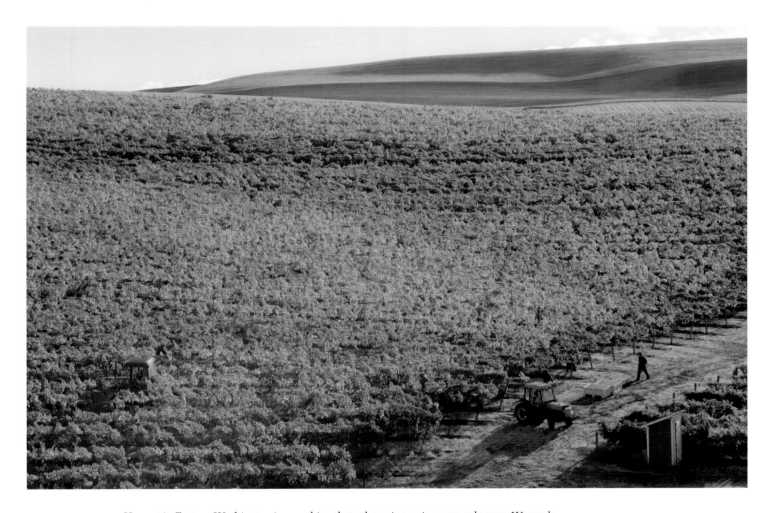

Harvest in Eastern Washington is something that other wine regions can only envy. We rarely get rain at this crucial time. And the grapes have ripened so beautifully in the long, hot days that we know we can count on wines with wonderful fruit. It gives ua a huge advantage in planning the firt stages of winemaking in the cellar. Consistent, consistent, consistent. Year after year after year.

Doug Gore

SENIOR VICE PRESIDENT FOR WINEMAKING AND VITICULTURE, STE. MICHELLE WINE ESTATES

■ RIGHT: White Riesling grapes during harvest in Red Willow Vineyard, near Wapato in the Yakima Valley AVA. Packing into small bins protects the hand-harvested clusters from damage on their way to the winery.

■ OPPOSITE: Harvest of Cabernet Sauvignon grapes in DeLille's Grand Ciel Vineyard in Red Mountain AVA.

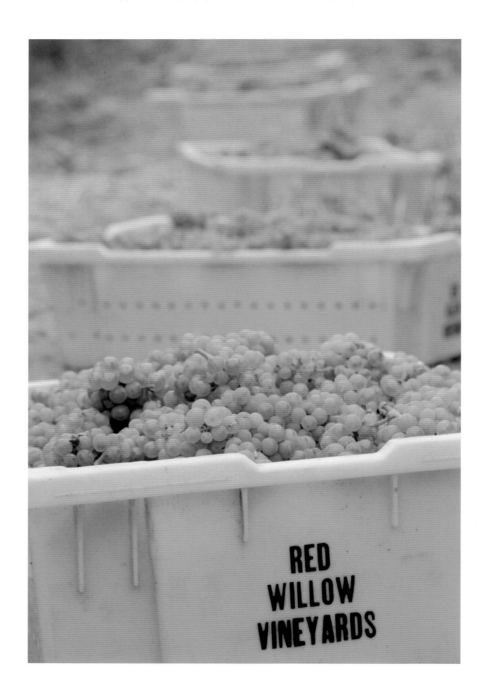

The convergences of physical forces that define the Columbia Valley are unique in the world. The low rainfall, quick draining, low fertility soils, long days, cloudless skies, and south-facing slopes provide one of the most cherished spots for growing classic grapes. The result is a range of varieties that retain fruit intensity and purity, and have a structural integrity.

~ Bob Betz

WINEMAKER AND OWNER,
BETZ FAMILY WINERY

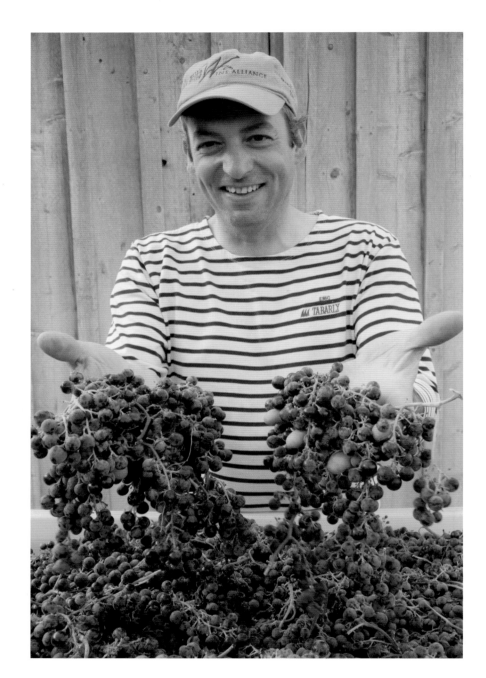

■ RIGHT: Winemaker Serge Laville with Merlot grapes at Spring Valley Vineyard.

■ OPPOSITE LEFT: Grape-picking team in DeLille's Grand Ciel Vineyard in Red Mountain.

■ OPPOSITE RIGHT: Cabernet Sauvignon grapes at Grand Ciel.

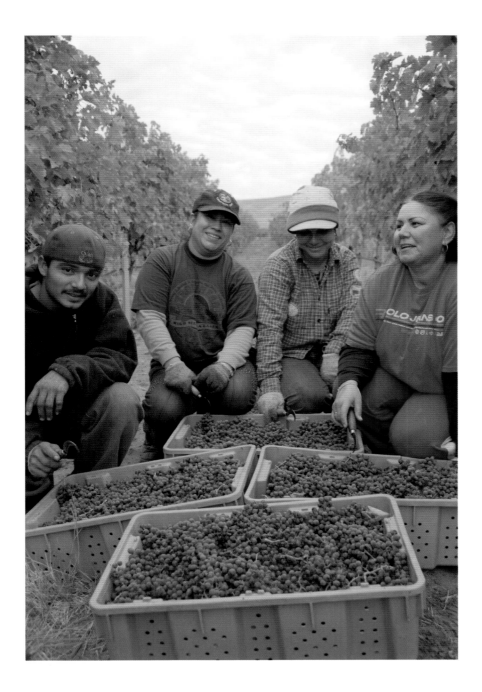

Grape yields on Red Mountain's slopes are low, due to the very poor, quick-draining sandy soils, and the lack of water. But with small berries and thick skins hardened by the constant southwesterly winds, the grapes yield dark wines with big structure that linger on one's palate. Red grapes are king on Red Mountain!

~ *Tom Hedges*
FOUNDER AND OWNER,
HEDGES FAMILY ESTATE

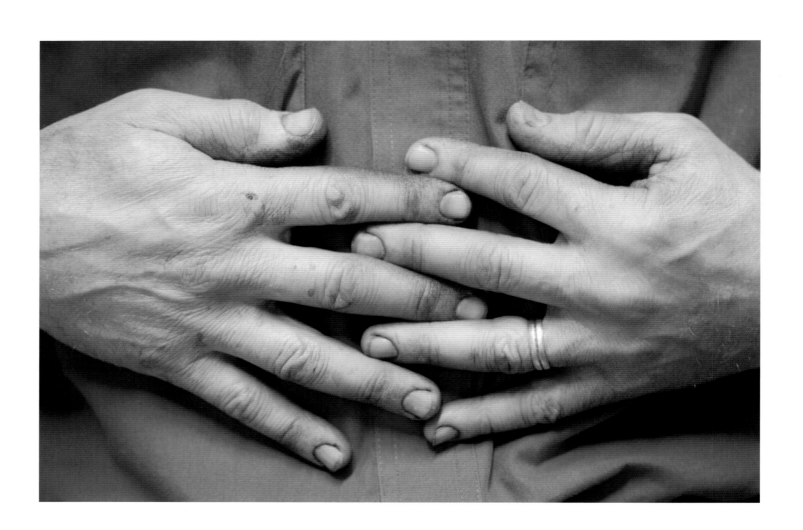

Winemaking

As yeast consumes sugar during fermentation, the alcohol level rises. Daily monitoring of this conversion assures the winemaker that the yeast is happy and vigorous.

Grapes demand attention throughout fermentation. Extracting their essence by frequent mixing of the juice and skins nets rich flavor and aroma.

The gentle action of a basket press yields wines with abundant flavorful skin tannins and few harsh seed tannins.

While fermentation and maturation are natural processes, today's winemakers use a wide range of techno-skills to assure a more flawless wine. But the savvy winemaker also trusts artistic instincts to craft the final wine to deliver pleasure at the table.

Bob Betz

WINEMAKER AND OWNER, BETZ FAMILY WINERY

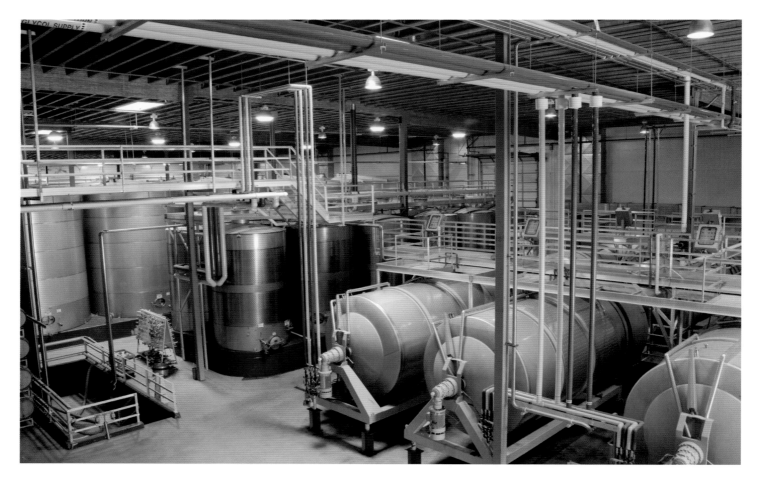

As the Washington wine industry has grown to become a world-class winemaking region so has its appetite for pursuing technology to better improve the winemaking techniques. Even old-world concepts, coupled with new-world technology in the way of twenty-first-century computer-programmed basket presses, show us that what was once old is still new when forward-thinking technology is applied to age-old technique.

Greg Lill
OWNER / PARTNER, DeLILLE CELLARS

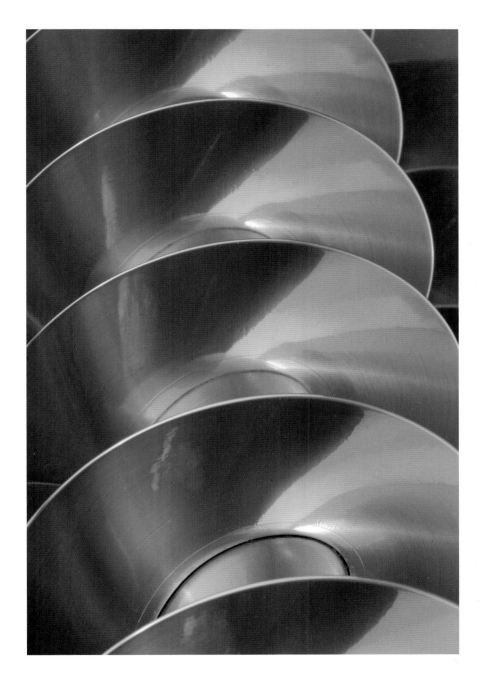

■ PREVIOUS PAGE: Owner and winemaker Bob Betz's wine-stained fingers during harvest.

■ OPPOSITE: These horizontal fermenters rotate to increase contact of the fermenting wine with the grape skins at Columbia Crest Winery, Horse Heaven Hills AVA.

■ LEFT: This stainless steel auger gently feeds hand-harvested grapes into a destemmer/crusher at L'Ecole Nº 41.

■ RIGHT: Grapes being pressed in a basket press at Betz Family Winery.

■ OPPOSITE LEFT: Pouring fermented grapes and the free-run juice into the basket press at Cayuse Vineyards in Walla Walla.

■ OPPOSITE RIGHT: The French-made Vaslin Boucher press at Cayuse Vineyards.

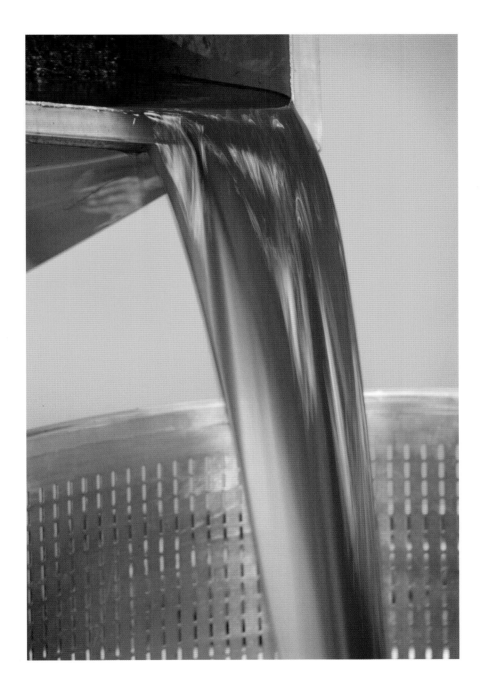

A soft gentle pressing of the skins helps the winemaker to dial in the ideal balance of fruit flavors with the firm structure and tannins in the wine. We prefer limited manipulation and handling of the fruit, exemplified by gravity-assisted fruit movements, without the use of a must pump. Pouring the fermented grapes directly from the fermentation bin into the press provides for gentle handling with that ideal oxygen pickup to help facilitate a clean final finish to the fermentation.

~ *Marty Clubb*
OWNER AND WINEMAKER,
L'ECOLE N° 41

To transform great fruit into great wine, modern-day winemakers use state-of-the-art stainless steel tanks, chilling equipment, and fermenters to extract the most flavor and character for each vineyard lot of fruit. White wines are cold stabilized in stainless steel tanks to precipitate naturally occurring potassium tartrate crystals, which would otherwise form in the bottle.

~ Marty Clubb

OWNER AND WINEMAKER, L'ECOLE Nº 41

■ OPPOSITE: Frozen condensed water on a stainless steel tank at L'Ecole Nº 41.

■ LEFT: Stainless steel clamps at the Columbia Winery used to attach hoses to large tanks. Keeping everything in the winery well organized and spotlessly clean is important in making great wine.

I love machinery. But the great equipment we use in winemaking is nothing without the right people to operate and maintain it.

~ *Rich Small*

OWNER AND DIRECTOR OF PRODUCTION,
WOODWARD CANYON WINERY

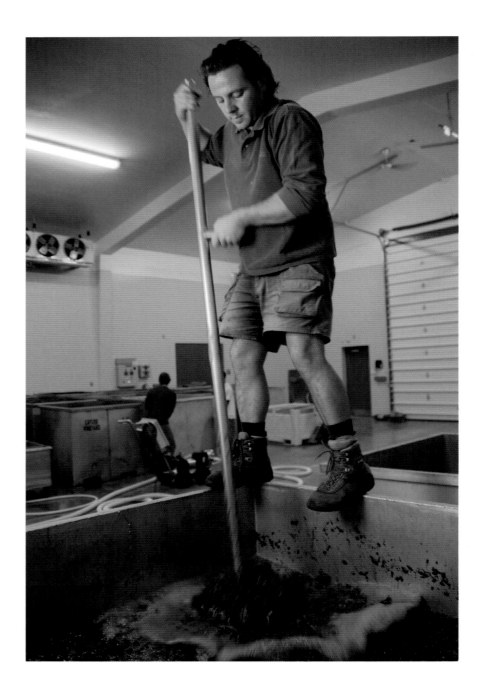

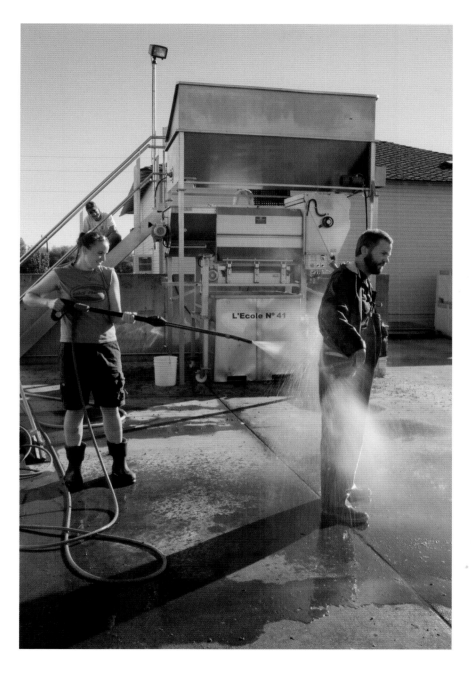

■ OPPOSITE LEFT: Testing fermenting wine to determine the Brix (sugar content).

■ OPPOSITE RIGHT: Christophe Baron "punching down" fermenting wine at Cayuse. This is one method used to increase contact between the skins, where the color and many of the flavors reside, and the juice.

■ LEFT: It takes a lot of water to make wine, they say. Cleanup is a big part of winemaking, including the use of a power washer.

■ BELOW: These fermenting bins at Cayuse have been washed, and the winemaking team of Christophe Baron, Stephen Thompson (center), and Marco Martinez (right) have to work together to wrestle them back into the winery for another round of fermentation.

The ability to control temperature during fermentation has made steel tanks essential to many wineries. Wines that stay in steel until bottling, such as Riesling and Pinot Gris, and some Sauvignon Blancs, are meant to be more focused and not as round on the palate.

Doug Gore

SENIOR VICE PRESIDENT FOR
WINEMAKING AND VITICULTURE,
STE. MICHELLE WINE ESTATES

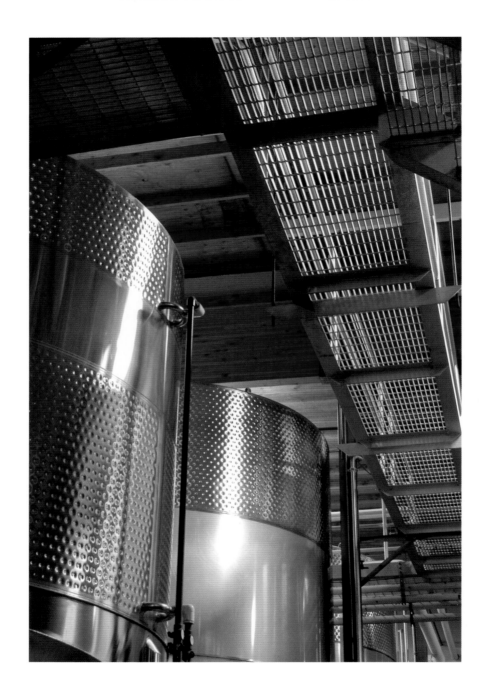

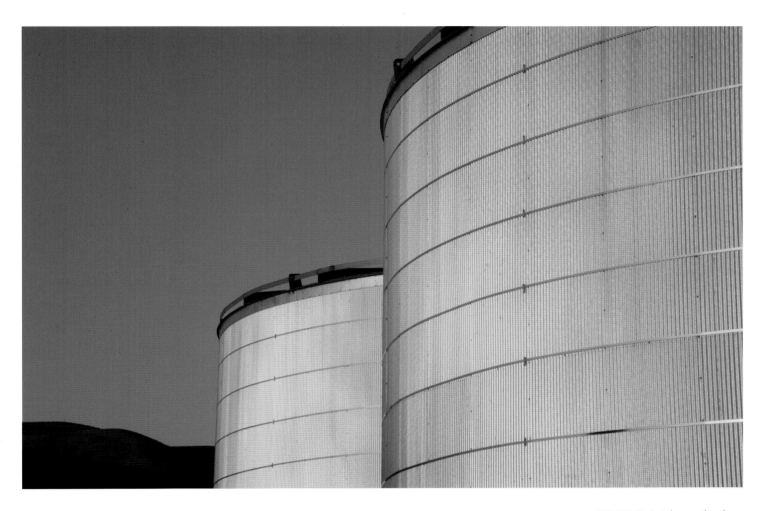

■ OPPOSITE: Stainless steel tanks at Columbia Winery in Woodinville.

■ ABOVE: Large tanks at Snoqualmie used for blending wines.

■ OPPOSITE and ABOVE: The insulated tanks at Snoqualmie are covered with corrugated aluminum, which glows at sunrise.

■ RIGHT: Wines are filtered in machines like this at Chateau Ste. Michelle before bottling to remove imperfections and sediment, making a cleaner product.

■ OPPOSITE: The bottling line at Chateau Ste. Michelle bottles 140 bottles per minute.

Bottling lines are the cleanest machinery in a reputable winery. It is the last time the wines can be exposed to harmful elements before the journey to the consumer.

Ray Einberger

HEAD WINEMAKER, COLUMBIA CREST

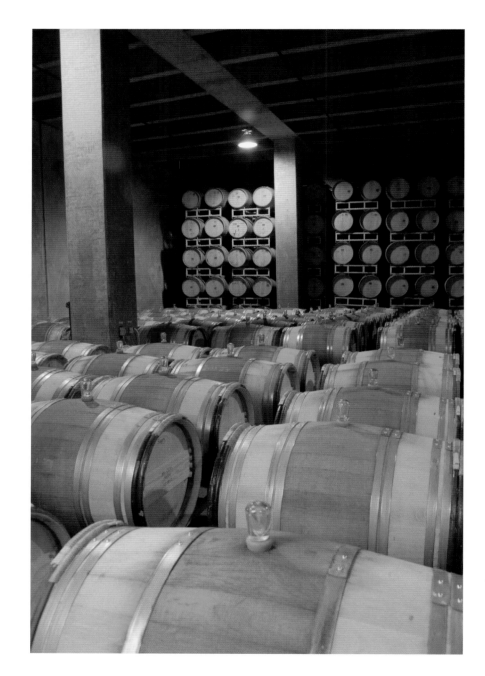

Barrel maturation is an essential component of most red wines and some whites. But that is where agreement among winemakers ends. Ask any four winemakers about oak types, coopers, toast levels, or time in barrel, and you'll get four different answers.

Bob Betz
WINEMAKER AND OWNER,
BETZ FAMILY WINERY

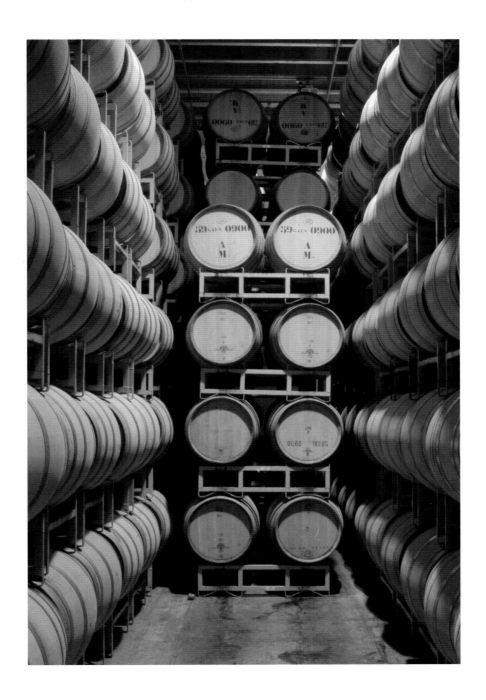

■ OPPOSITE: Barrel cellar at Columbia Crest Winery near Patterson, in the Horse Heaven Hills AVA.

■ LEFT: Barrels stacked six high at Chateau Ste. Michelle in Woodinville.

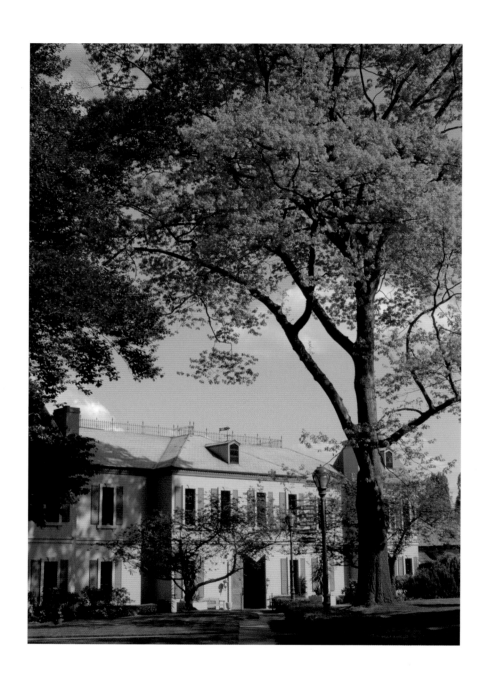

CHAPTER SIX

Wineries

———

Each year, people from all over the world discover that Washington State is a premier wine region. Fortunately, we have some beautiful wineries to welcome these visitors and offer them a special experience.

There are elegant tasting rooms with their serving bars and rows of different wines to compare. There is the enticing scent of wine aging in oak barrels that come from forests in France, America, and other countries. At some wineries, peacocks roam manicured grounds, cats snooze near crush pads, and dogs lounge under shade trees.

Does all of this enhance the wine-tasting experience? Well, if you've done it, you know the answer is yes. And if you haven't, come to Washington and sample our hospitality at wineries throughout the state. We guarantee you will come back.

~ Ted Baseler ~

PRESIDENT, STE. MICHELLE WINE ESTATES

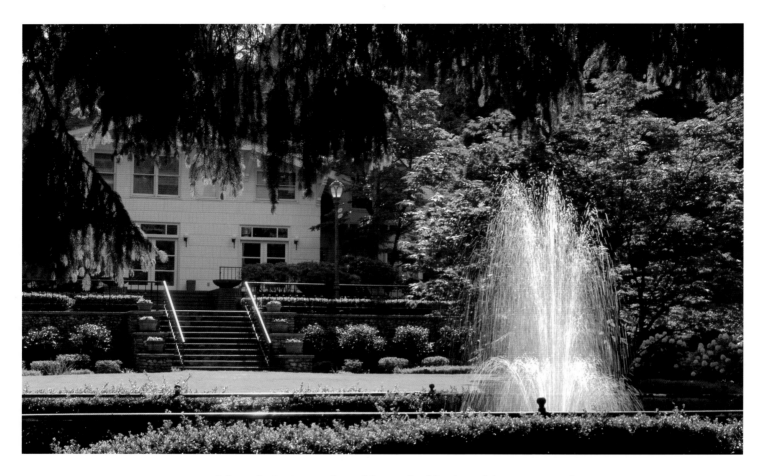

A drop of wine is not only good for your health, it's good for tourism. Washington State is quickly building a reputation as a quality wine and culinary tourism destination for wine lovers around the world. With more than 30,000 vineyard acres and 400 wineries in virtually every corner of the state, visitors to Washington wine country can meet one-on-one with winemakers, stroll the vineyards, enjoy gourmet cuisine, and sample award-winning wines.

Robin Pollard

EXECUTIVE DIRECTOR, WASHINGTON WINE COMMISSION

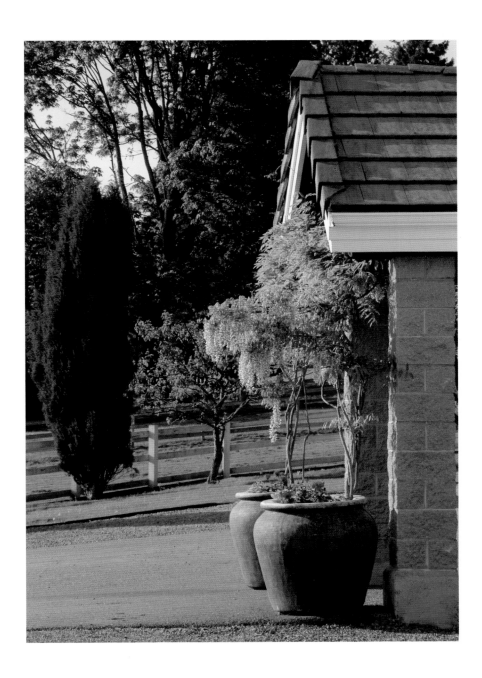

■ PREVIOUS PAGE: The main façade of Chateau Ste. Michelle in Woodinville.

■ OPPOSITE: The old manor house on the property of Chateau Ste. Michelle, built in 1911.

■ LEFT and BELOW: Gardens at DeLille in Woodinville.

■ RIGHT: The tasting room at L'Ecole Nº 41 is housed in an old schoolhouse (ca. 1915) near Walla Walla.

■ BELOW: The tasting room at Woodward Canyon is in a restored 1870s farmhouse outside Walla Walla.

■ OPPOSITE: The name for L'Ecole Nº 41 is French for "the school" located in district number 41.

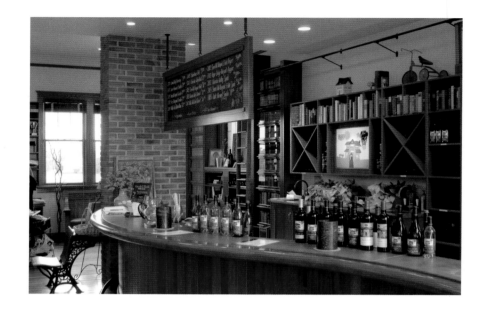

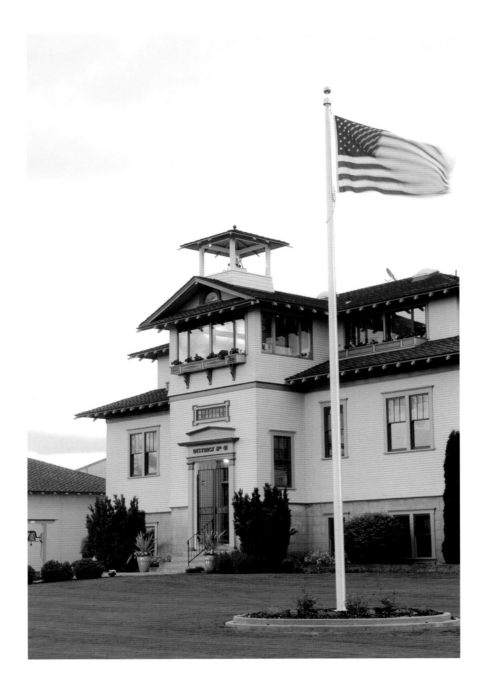

One of the more engaging aspects of the Washington wine industry is that wine tourists can often meet and talk with the owners and winemakers as so many of the more than four hundred wineries are still owned and operated by the pioneering families that started them.

~ John Bookwalter

OWNER AND WINEMAKER,
BOOKWALTER WINERY

■ RIGHT: A chandelier at Quilceda Creek.

■ OPPOSITE: Riedel stemware at Quilceda Creek.

I love a big glass. It gives me plenty of room to swirl and slosh the wine around without spilling it and then the aromas explode. A large bowl with a tapered opening concentrates the full impact of the wine in the nose and actually delivers it to the tongue in the most attractive way.

Bob Betz

WINEMAKER AND OWNER,
BETZ FAMILY WINERY

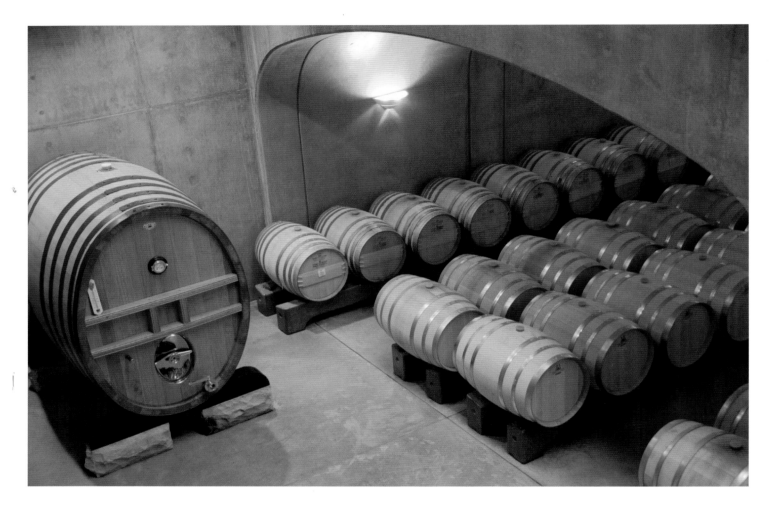

■ ABOVE: Barrel cellar at Leonetti in Walla Walla.

■ OPPOSITE: This building at Leonetti was used as the winery until it was replaced by a newer facility in 2001.

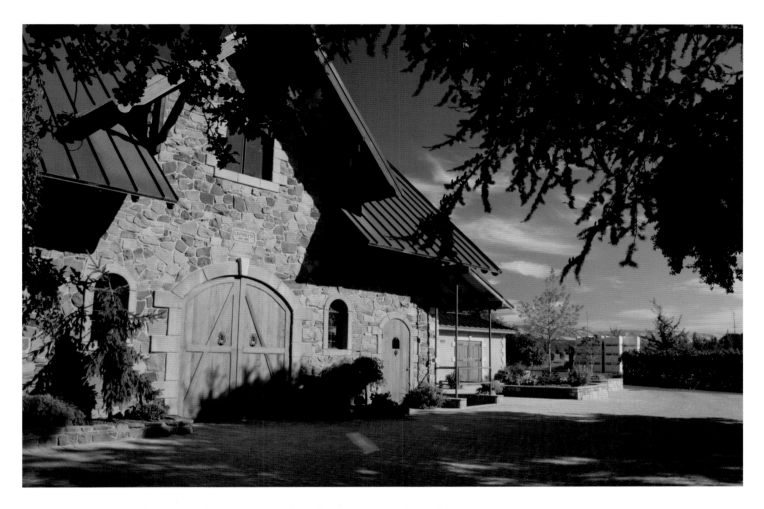

At fifty years old, the Washington wine industry is emerging from adolescence and taking its rightful place on the world's wine stage. It's only a matter of time before the words "Columbia Valley" flow from the lips of wine lovers worldwide as easily as "Bordeaux" and "Tuscany."

Bob Betz

WINEMAKER AND OWNER, BETZ FAMILY WINERY

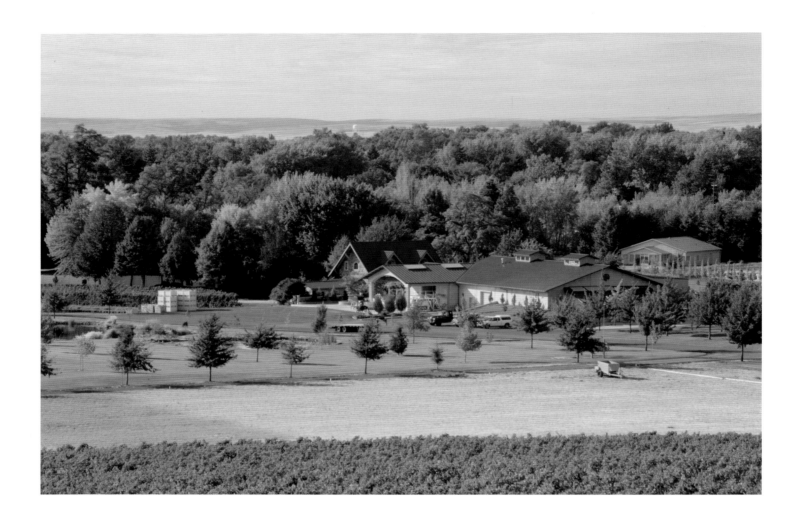

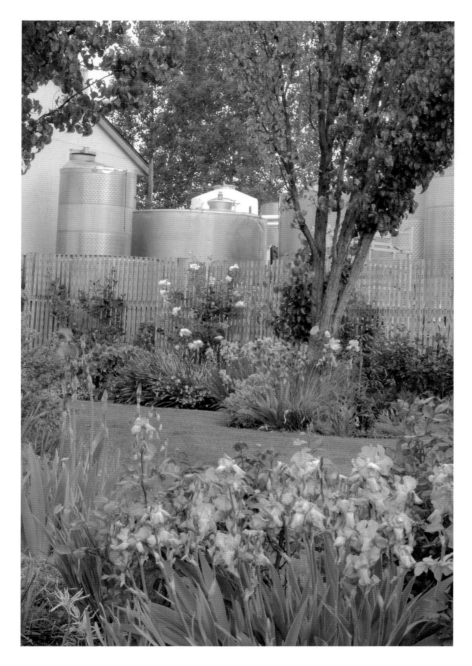

■ OPPOSITE: Leonetti Cellar, with the Loess Vineyard in the foreground.

■ LEFT: Iris in bloom in the garden at Bookwalter in May.

■ ABOVE: Leonetti Cellar's new winery in Walla Walla.

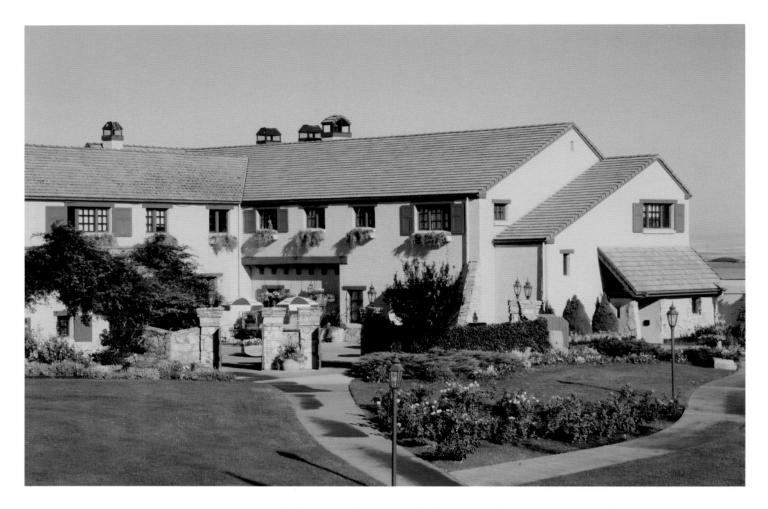

Our concept for the winery's bistro is to offer the samples of our wine paired with food in a

relaxing and inviting atmosphere. We want our guests to slow down, relax, and truly taste the

wine and to see how the wines pair with artisan cheeses and foods from around the region.

~ John Bookwalter ~

OWNER AND WINEMAKER, BOOKWALTER WINERY

■ OPPOSITE: The winery and tasting room at Columbia Crest in the Horse Heaven Hills.

■ LEFT: The new winery at Northstar in Walla Walla.

■ BELOW: The outdoor tasting room at the Bookwalter Winery comes alive in summer with live music.

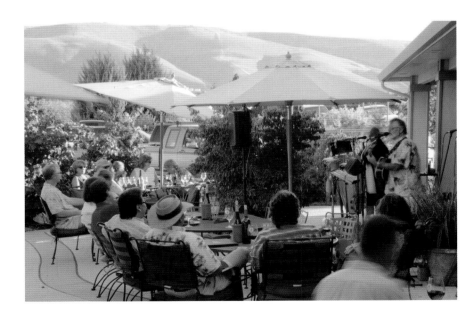

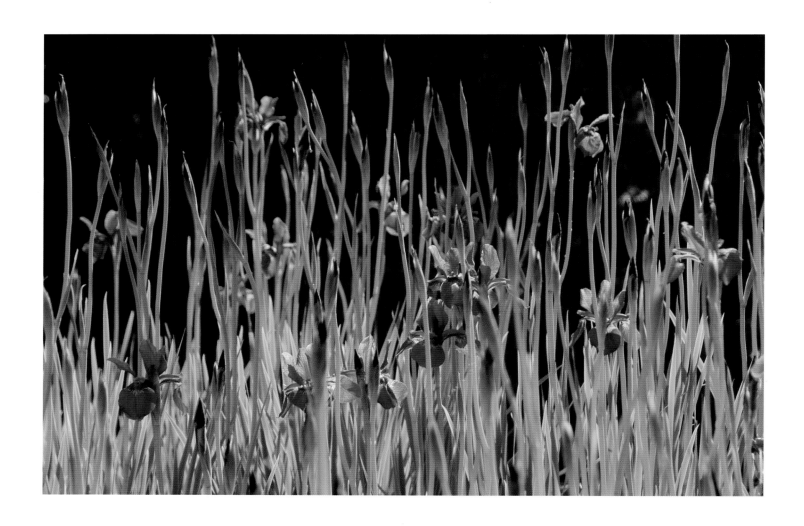

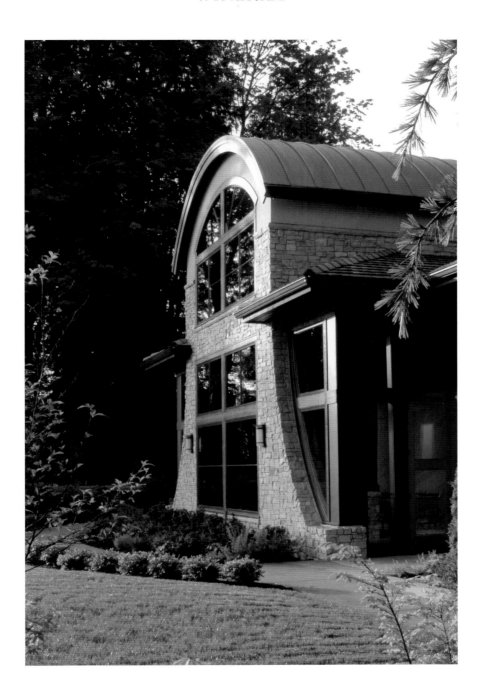

■ OPPOSITE: Iris in the garden outside Columbia Winery's tasting room.

■ LEFT: The new winery at Quilceda Creek was completed in 2004.

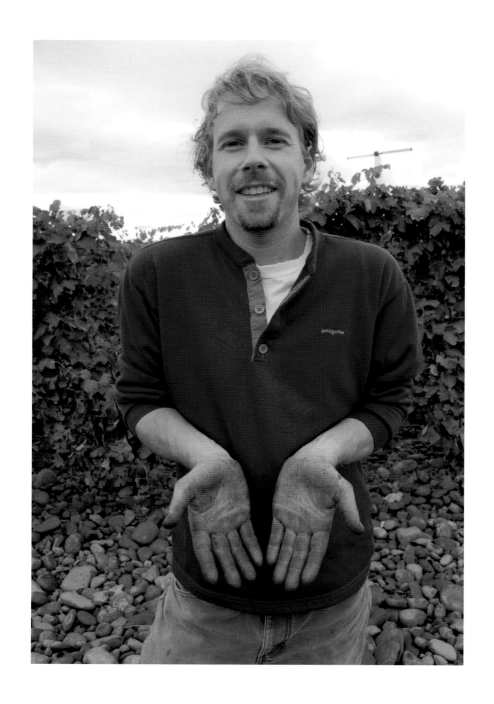

People

We're at a special place in today's Washington winemaking community; we have a fraternity that is unlike anywhere else in the world. The relationship between grower and winery is focused on quality in the bottle, and most growers and winemakers eagerly pitch in to help a neighbor in need with advice, equipment, or a genuine pat on the back. The winegrowers and winemakers in Washington realize that there is no substitute for quality at every step of the process. Over the years grape growers have become winegrowers, working closely with winemakers to yield the fruit quality capable of making world-class wine.

~ Bob Betz

WINEMAKER AND OWNER, BETZ FAMILY WINERY

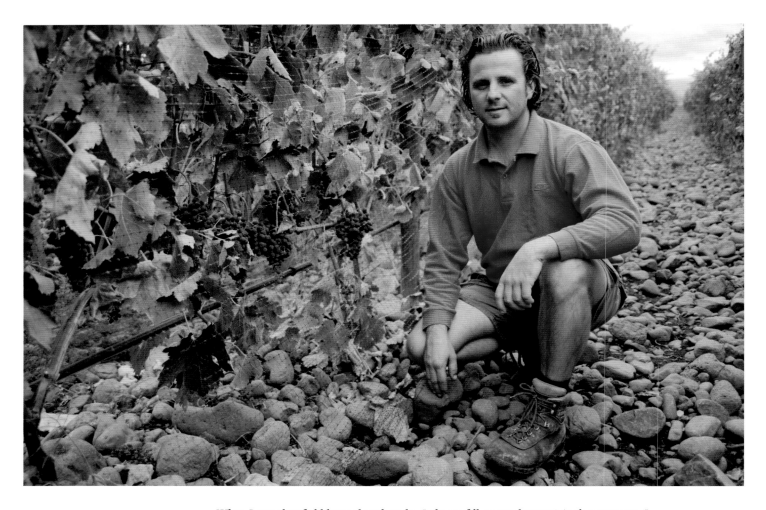

When I saw that field littered with rocks, I almost fell on my derriere! At that moment, I knew this was the place. Since then I've been living in a dream. Walla Walla brings together all the elements to create distinctive wines.

Christophe Baron
VIGNERON, CAYUSE VINEYARDS

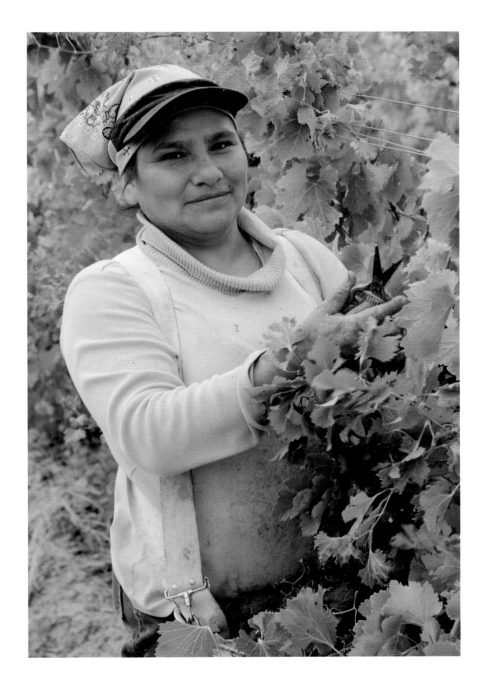

■ PREVIOUS PAGE: Assistant wine-maker Stephen Thompson shows the results of harvest time on his hands. The vineyards at Cayuse are known for their abundance of cobble-stones.

■ OPPOSITE: Vigneron Christophe Baron in his distinctive Armada Vine-yard at Cayuse.

■ LEFT: Victoria Brito harvests grapes at Spring Valley Vineyard.

■ CLOCKWISE (from top left): Paul Champoux, owner and operator, Champoux Vineyards • Jerry Bookwalter, owner and winemaker, Bookwalter Winery • Walter Clore, "Father of Washington Wine," 1911–2006 • Meryl Rickey, enologist, Snoqualmie.

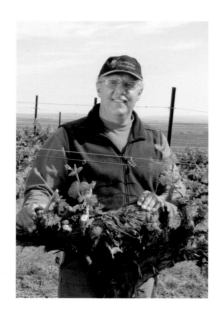

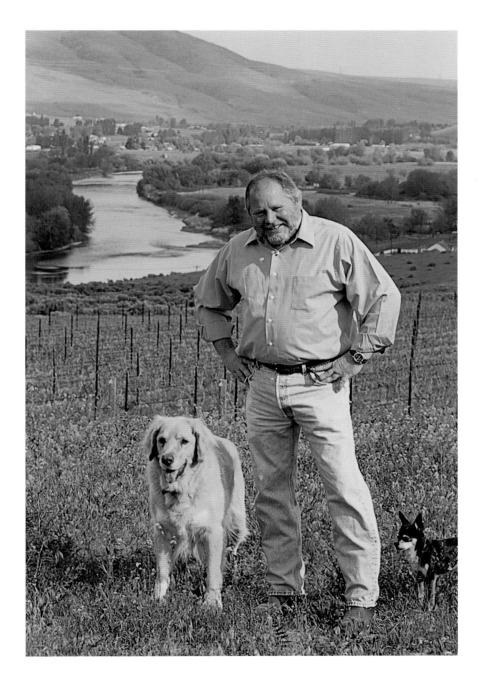

There are certain common denominators in the faces of all us Walla Walla vintners. The obvious ebullient enthusiasm of the youthful only fades slightly into a certain pride hidden in the labor and sun-induced furrows in the faces of our elders.

~ *Chris Figgins*
LEONETTI CELLAR

■ LEFT: Fred Artz in his vineyard adjacent to the Yakima River in the Red Mountain AVA.

■ CLOCKWISE (from top left): Mimi Nye, Canoe Ridge Estate vineyard manager for Ste. Michelle Wine Estates • Brennon Leighton, assistant winemaker, in the Canoe Ridge Estate Vineyard, Ste. Michelle Wine Estates • Dick Boushey, owner, Boushey Vineyards near Yakima • Chris Figgins, Leonetti Cellar.

Rare among the wine industries of the world is a remarkable unity of purpose between the growers and the wineries of Washington. The universal concern of all is to ensure and promote the high quality and reputation of Washington wine. We are a young industry with great vitality and enthusiasm. We know that Washington is a uniquely special place to grow distinctive wines, and it is our conviction that it is destined to enter the top echelon of the world's classic wine regions.

David Lake

DIRECTOR OF WINEMAKING,
COLUMBIA WINERY

■ LEFT: Gary Figgins, Leonetti Cellar.

■ CLOCKWISE (from top left): Doug Gore, senior vice president, winemaking and viticulture, Ste. Michelle Wine Estates • Bob Betz, winemaker and owner, Betz Family Winery • Ray Einberger, head winemaker, Columbia Crest Winery • Marty Clubb, owner and winemaker, L'Ecole N° 41.

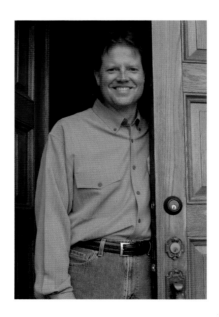

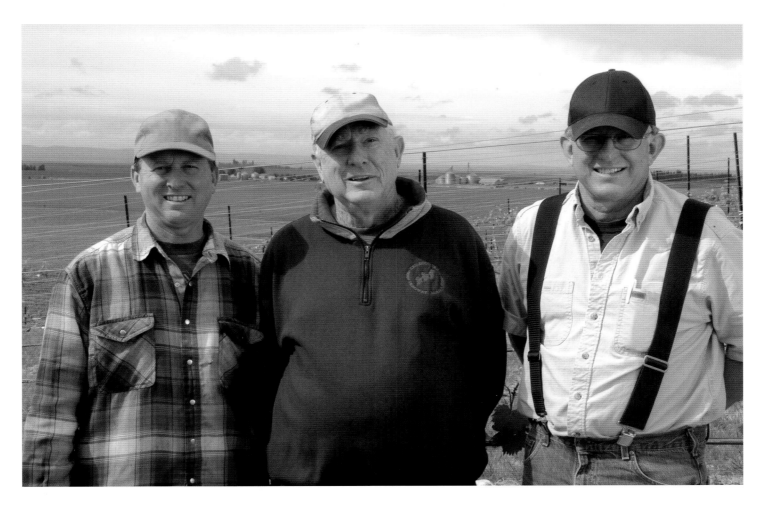

Many of the early grape growers were from farming families that date back two, three, and four generations on the land. Farmers, agriculturalists, people of the soil that know the land and would forever fall in love with this new crop, wine grapes.

~ *Mike Sauer*

OWNER, RED WILLOW VINEYARD

■ ABOVE: Rob (left) and Mike (right) Andrews with their father, Bob Andrews, in their Coyote Canyon Vineyard in the Horse Heaven Hills AVA.

■ RIGHT: Carmen Betz in the winery at Betz Family Winery.

■ OPPOSITE: Mike Sauer of Red Willow Vineyard has been working with David Lake, master of wine and head winemaker at Columbia Winery (right) to produce high-quality grapes and wine for over thirty years.

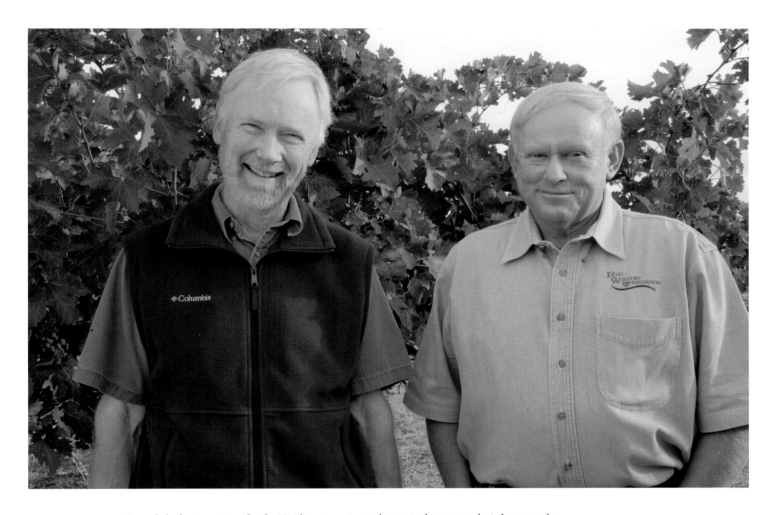

One of the best positives for the Washington wine industry is the camaraderie between the grower and the winery. We work well together to continually raise our quality standards and Washington's mystique in the world wine industry.

Paul Champoux

OWNER AND OPERATOR, CHAMPOUX VINEYARDS

■ ABOVE: Winemaker and owner
Rick Small of Woodward Canyon in
his old barn near Walla Walla.